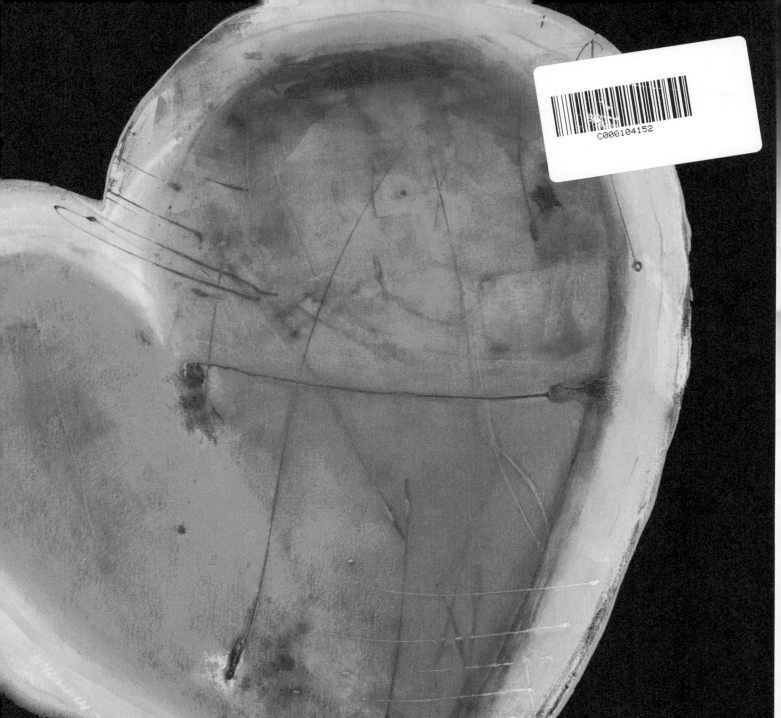

HEART QUAKES

All paintings and poems are originals by Åsa Katarina Odbäck.
Certain pieces are available for showings and purchase.
For more artwork, information or questions, please visit...

AsaKatarina.com

PEACEFUL VIKING BOOKS

PeacefulViking.com

Designed by Émile Nelson

Copyright © 2016 Åsa Odbäck & Émile Nelson

ISBN: 9780998445908

First Published in the United States of America by Peaceful Viking Books, 2016

HEARTQUAKES
PAINTINGS AND POEMS FOR HEALING HEARTS

Åsa Katarina Odbäck

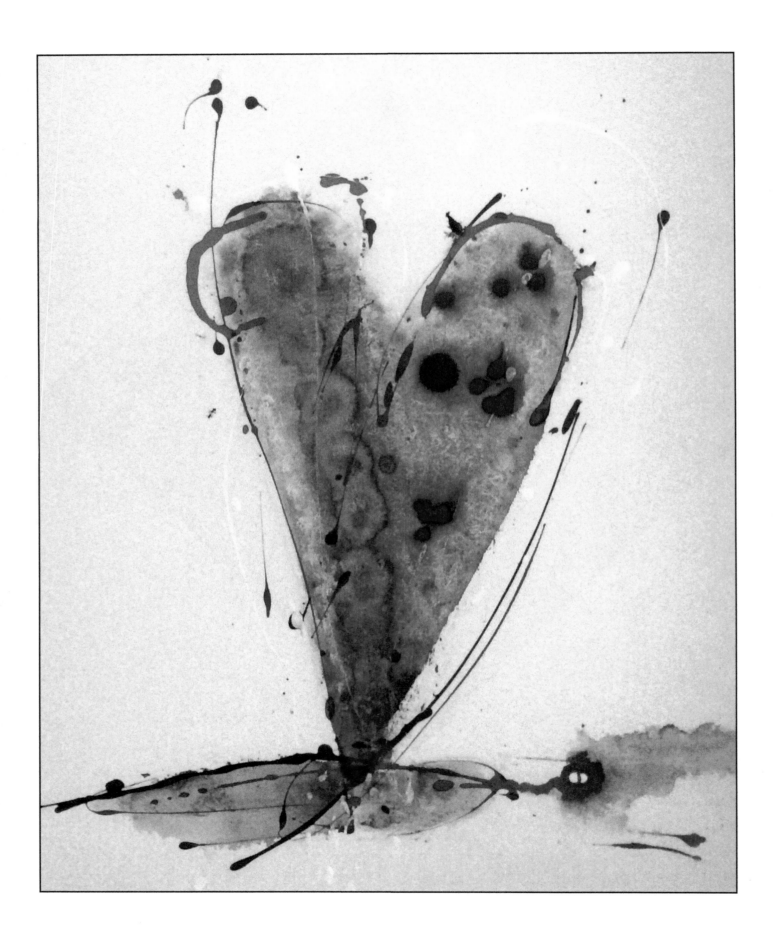

Välkommen Till
HEARTQUAKES

Courage comes from the French word for heart — *coeur*. To have the courage to live a fearless life, we need to be connected to our hearts. Sadly, many of us have learned to disconnect ourselves from our hearts because of all the heartquakes we've been through: from minor ones, like rejections, worries and disappointments, to major ones, like the end of a relationship or losing a loved one.

When we close our hearts off to pain, we also close ourselves off to the love, joy, wisdom and courage of our hearts, and we start to feel isolated, numb and out of touch — like we're missing something.

The poems I have collected in this book are from my own long and winding journey, and I have chosen them because they are based on some of the heartquakes many of us share: broken dreams, unfulfilled promises, losses, fears, etc. Each poem is paired with a painting that mirrors it in some aspect and provides a softer, more gentle type of healing that words simply cannot. Pictures "speak" to parts of us that our minds often prevent us from reaching with words or intellect, and can release feelings that we may be hiding from ourselves. So my hope is that the 100+ paintings in this book will touch some of those inexpressible parts within you and help you discover your own inner courage that has been there all along, hidden deep within your heart, waiting to be unleashed.

As you go through this book, maybe you will feel inspired to scribble down some words to make your own poems, or paint or draw some pictures yourself. You might be surprised what you can start to create if you just allow yourself to flow with it, instead of trying to make something "nice." Art therapy is actually one of the most effective therapies for helping us heal.

So if a poem or painting speaks to you, claim it as your own and use it to energize, heal and inspire you! You might even find a painting that feels like the window you need to look deeper into your soul. Whatever experience you have, you are the one creating it — I am just honored to be the messenger, reminding you of the light and beauty you truly are.

From my heart to yours,

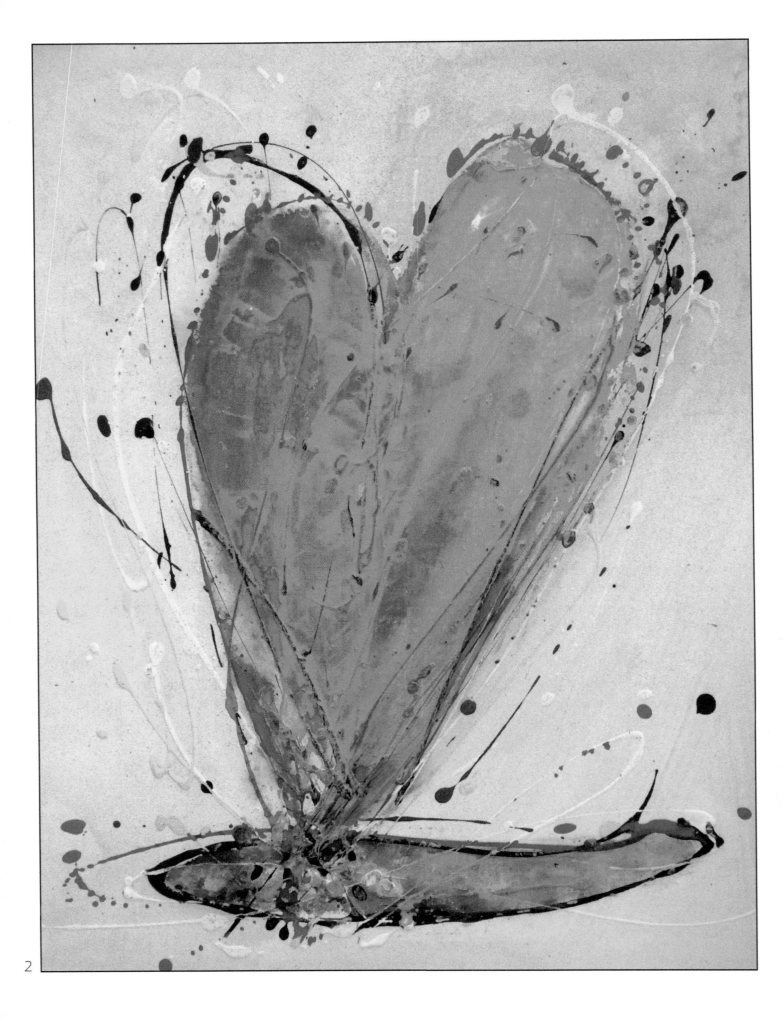

My Creative Process

People sometimes ask me about my creative process, and I often say, "I have no idea what I am doing or how I am doing it!"

The biggest part of my work is to make myself as clear and connected to the creative source as possible and then make my mind and ego step out of the way. I think some of the most important factors for me are to be really detached from the outcome and just devote myself fully to enjoying and trusting the creative process. It's a lot like life, I guess. Detach, have faith, flow and enjoy!

I listen to music and spiritual seminars while I paint and I just try to experience the joy of creating. Sometimes the energy is very light and playful and the paintbrush likes to dance over the canvases to the music, and I often find myself splashing paints in sync with the rhythm. I usually have no idea what the painting is before it's almost done — and I am often both surprised and delighted.

Creating for me is very easy — the hard part is to stop. When we connect to this powerful creative force it just feels like you could go on forever!

In the beginning of my career, it was hard for me to let anyone buy my art because each piece had so many different qualities that I was touched by and wanted to keep close. I was very reluctant to let go of any of my paintings, even though people really wanted to buy them. I later realized the paintings were meant for those who were touched by the light in them and could use them for their upliftment and healing. The paintings were given to me to share, not just keep for myself and my family.

I feel very privileged, and it brings me such joy to be able to bring the light and these subtle frequencies and energies to life on canvas. I just love painting, and I think many people can feel that love and joy in the paintings!

I also love hearing what a difference the paintings have made in people's lives:

> *"I sleep much better now with your painting over my bed." MT*
> *"Your lovely painting symbolized her transcendence so beautifully and vibrantly." DW*
> *"I saw that paining and I just knew it was mine and I started to cry." DM*
> *"The painting totally transformed the energy in our house." HF*
> *"Even though each painting is so different they all have one thing in common, there is a light coming through them and they make you feel good." MF*

I feel very honored that my art can be part of the healing process that so many of us are participating in. Now, more than ever, the world desperately needs our love and healing — and now, more than ever, there is so much light available to all of us if we just open up to it. I hope that my paintings and poetry can help inspire and lift you, and remind you of the loving, beautiful person you truly are!

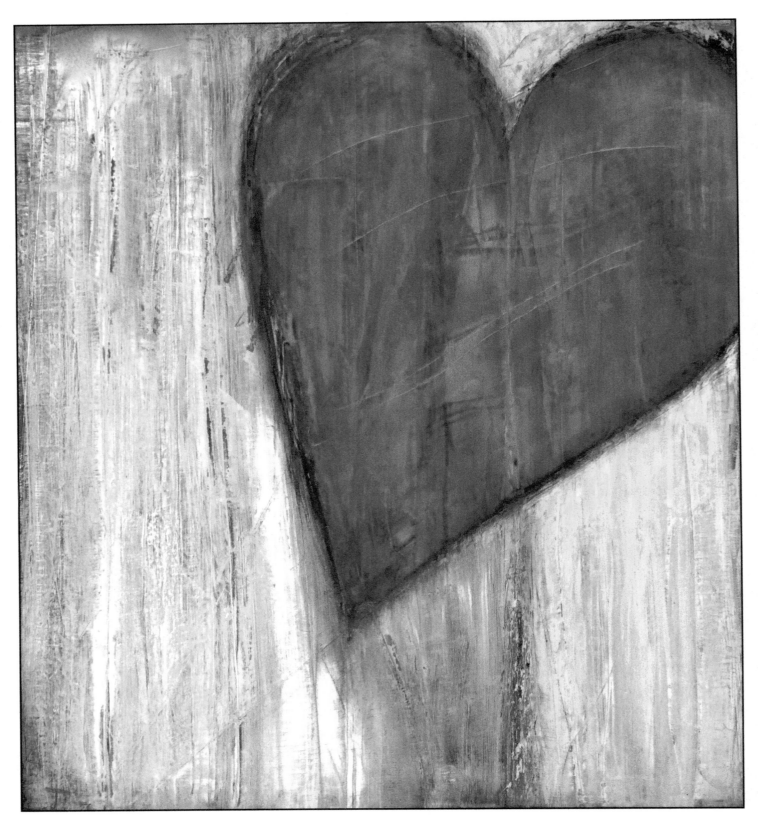

PLEASE

4

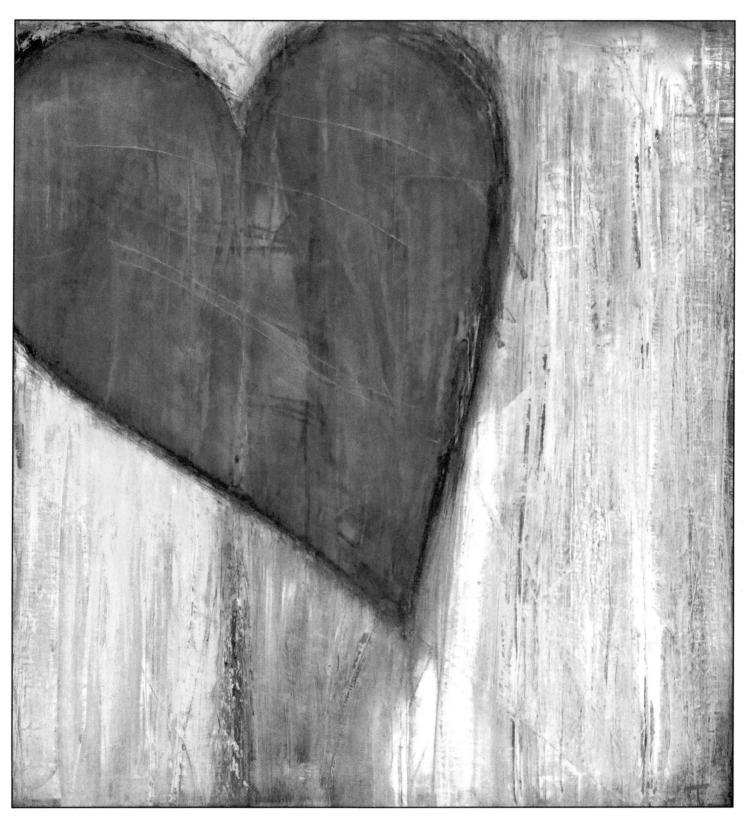

ENJOY

I lost me
when I tried
to find you

I lost you
when I tried
to find me

I found me
when I searched
for God

I found God
in an old wooden chapel
praying — for you

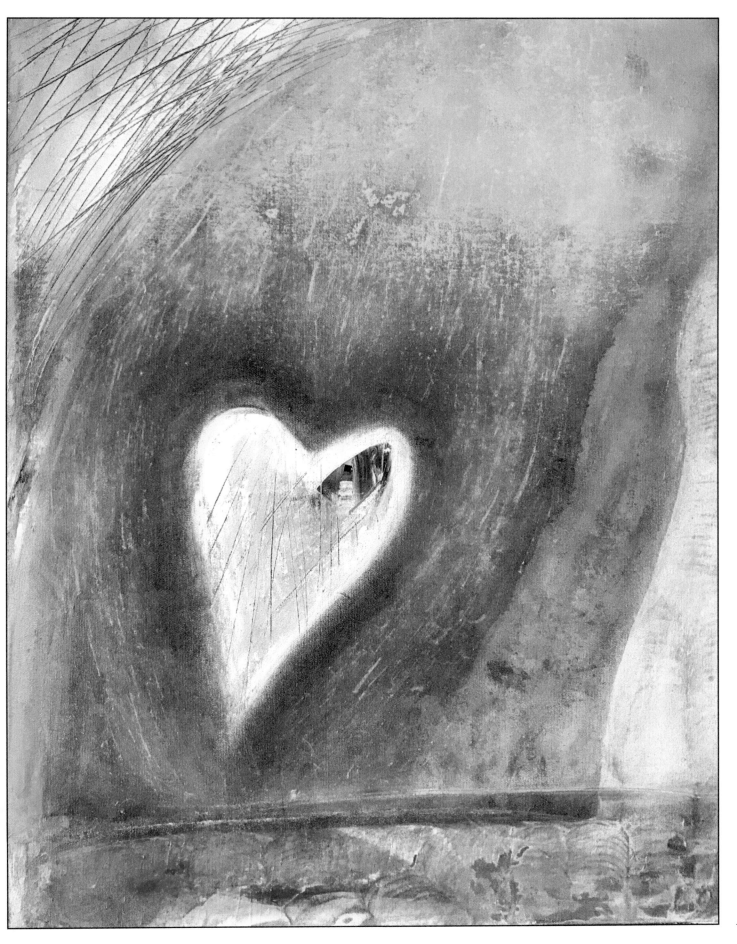

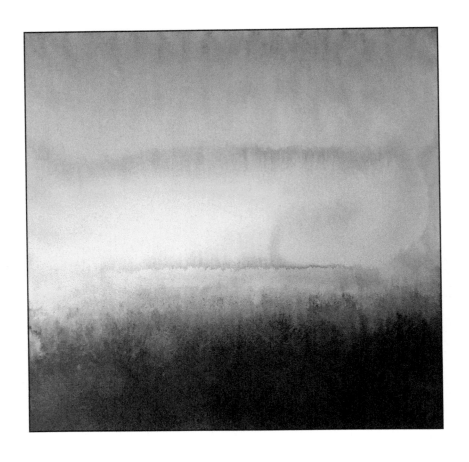

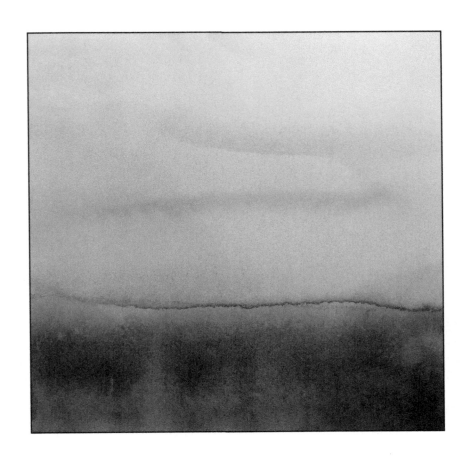

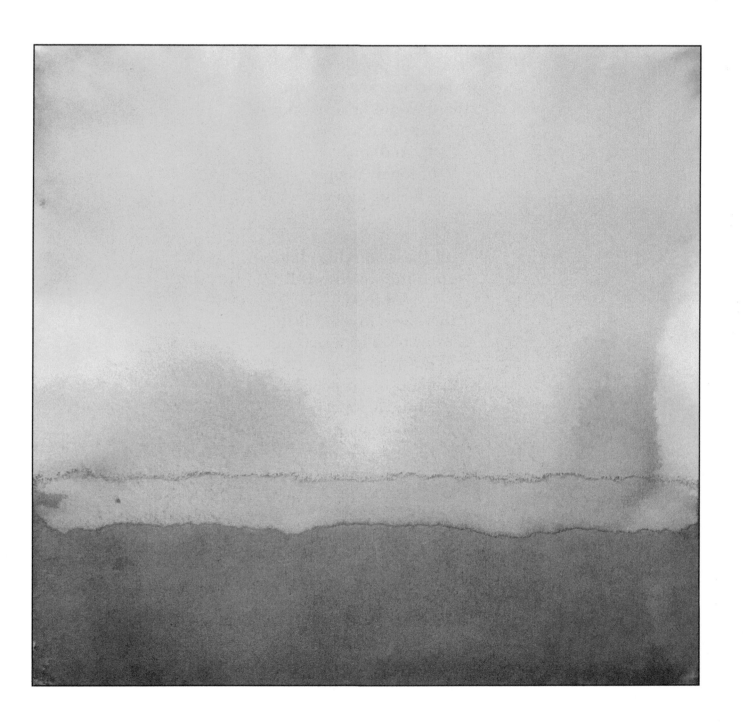

Why all these lonely people
when the world is full
of people
if there was just one of us
there would be a reason
but here we are
millions
of lonely people
feeling alone

Why all these starving children
when the world is full
of food
if there was just too little
there would be a reason
but here we are
millions of fat people
throwing away
our food

Why all these ugly feelings
when the world is full
of beauty
if there was just darkness
there would be a reason
but here we have the sun
filling the earth with light
and we close our eyes
and cry out
for the night
to end

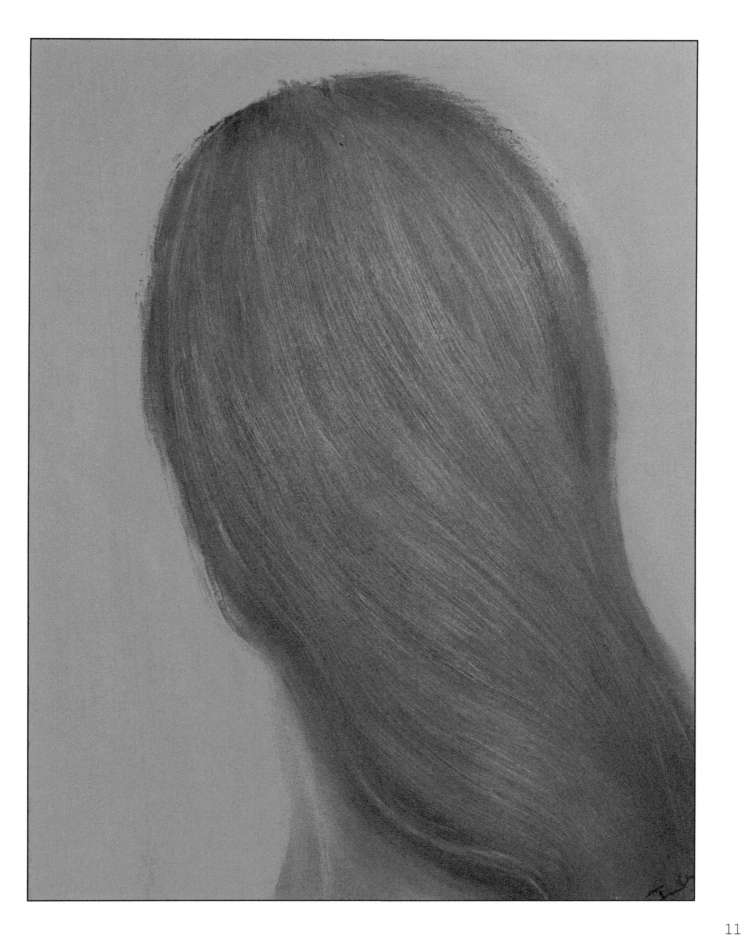

When fear was tiptoeing into my room
silently curling up by my side
I wanted to run
but paralyzed I stayed
frozen
unable to move
and I could feel her quiet breathing
like a small child
so alone
not loved by anyone

I carefully stroked her tangled hair
and rocked her to sleep
close to me
and I whispered in her ear
she will never again
be left alone
by me

I did not know
fears could smile in their sleep
if you just love them enough
I guess...

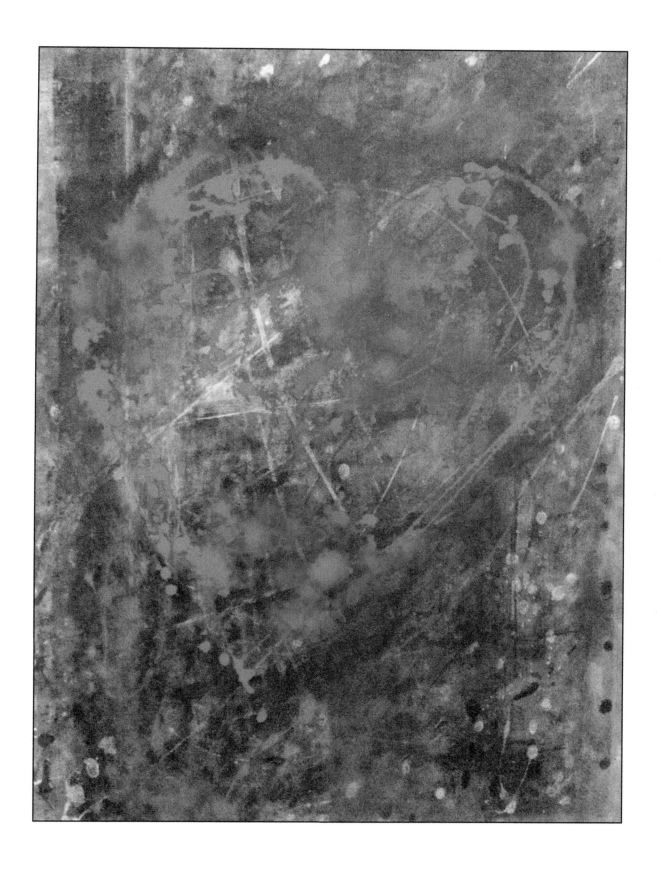

Comb my hair with your fingers
my hair will curl
that always before was so straight
and the stars will fall down
to be hairpins
in my curly hair
and he will smile
that made you do it — loving me
because you do
don't you?

 Just look at my curls...

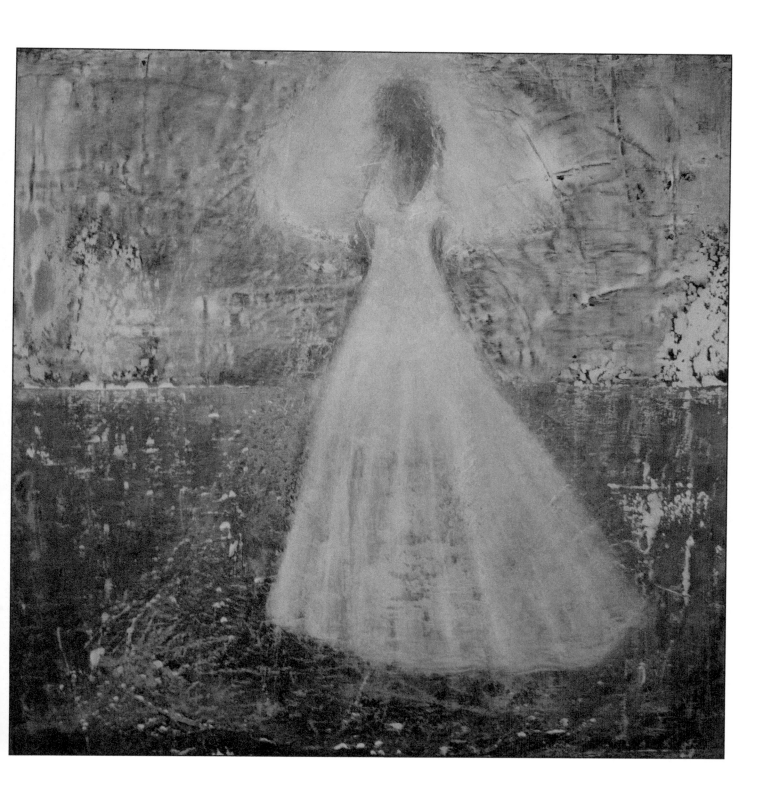

Memories of lost time
are blocking my vision
the shadows of your face
are in each window

I walk slowly
up to strangers
with backs
looking just like yours

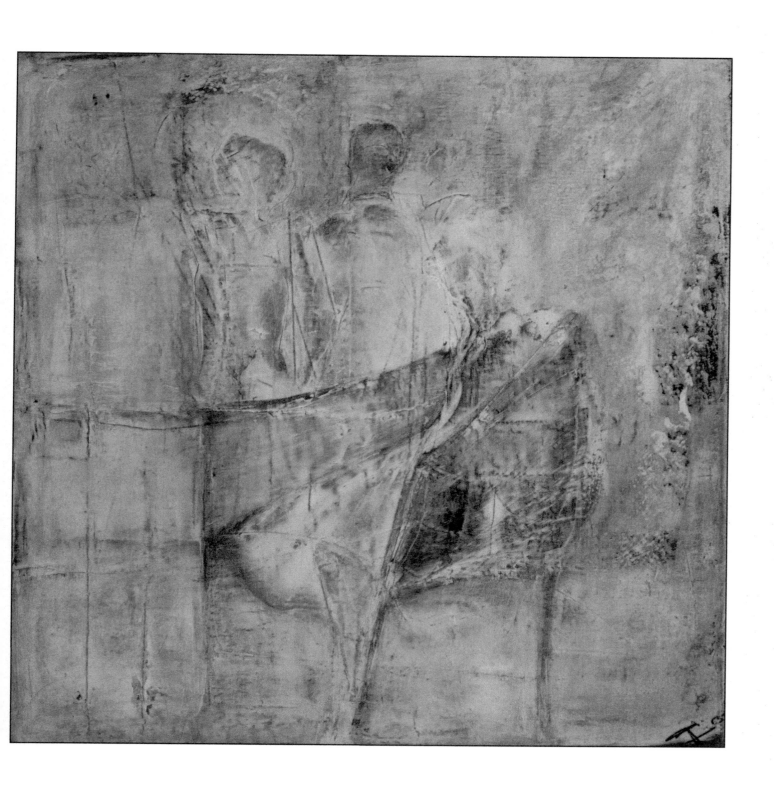

An egg
an unborn chicken
only a dream
before it manifests
hiding within its shell
but easily can be broken
by someone
who only wanted to fix
an omelet

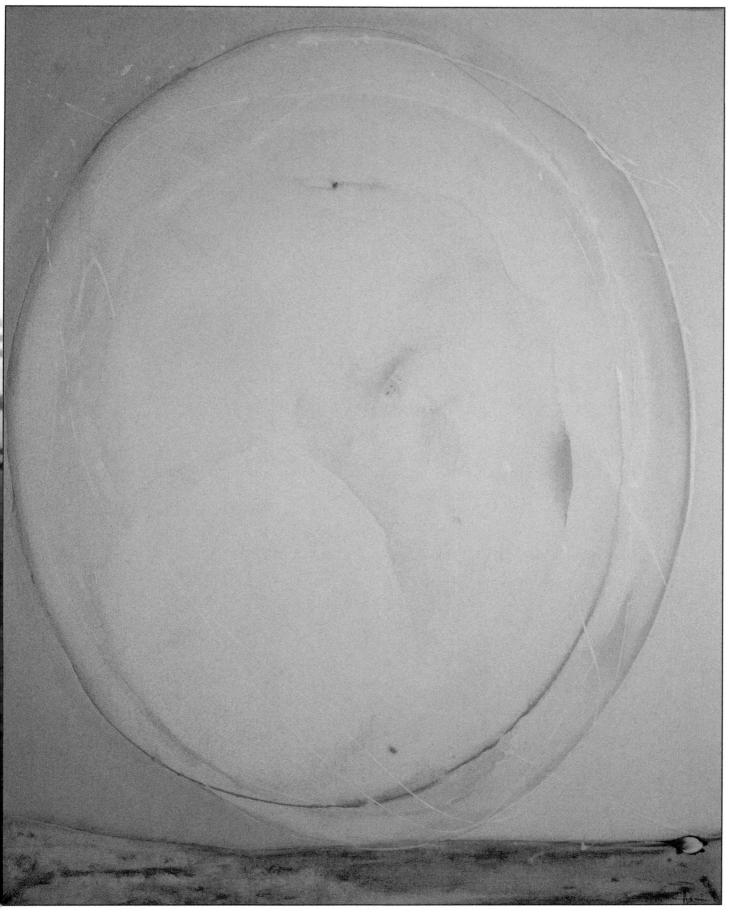

Sunsets and snowballs
she always collected them
and tried so hard
to hide them behind her smile
but we
who love her
would always remember
but pretend we had forgotten
and search under her cover
beneath that big bed monster and out in the hospital hall
while she laughed and covered her smile
with those giggling fingers
as all of us kept searching...
until she had just one silent sunset left

The winter sky was blooming
and filled with all those sunsets and snowballs
that she no longer was hiding
behind her smile
as she left
that evening
and us
behind

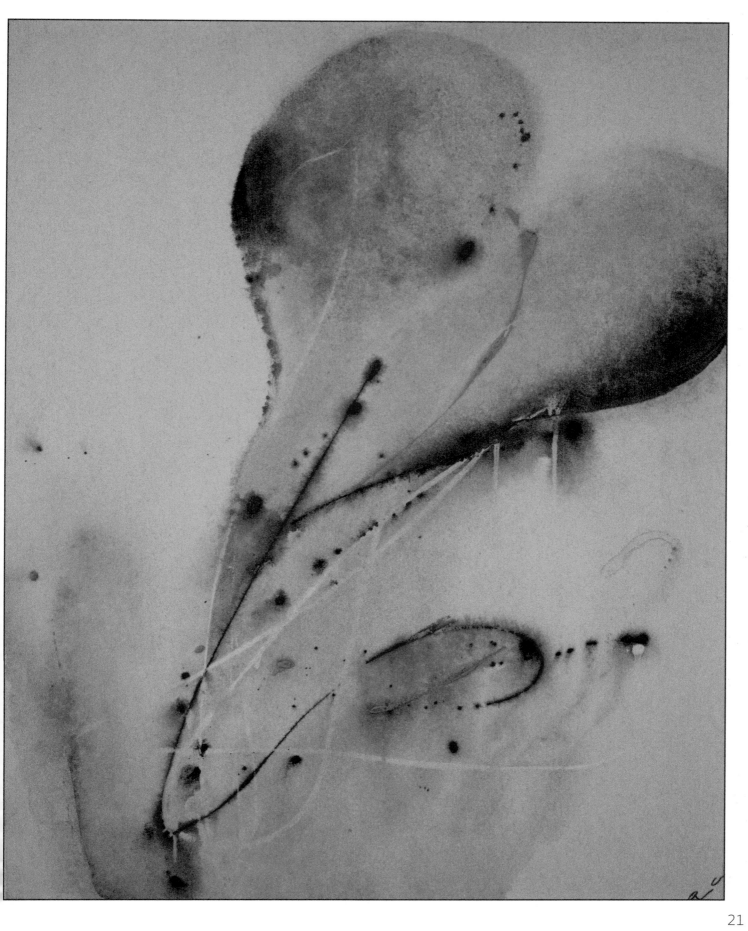

Learning to be still
in the middle of a storm
holding the breath
of the universe

Slowly bringing the rainbow
back to the sky
we help the storm
to surrender

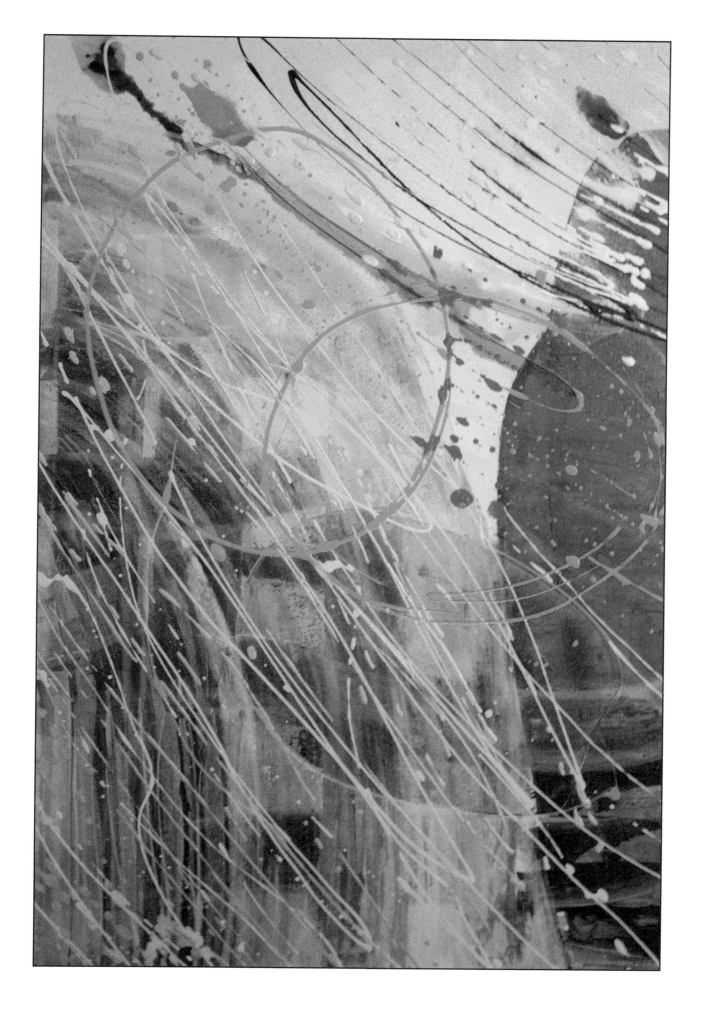

Keeping the darkness out
doesn't take force
but the lightness
of a butterfly
dancing on your skin

It takes total discipline
in keeping still
focusing on the magic
in a being so fragile
having the strength to overcome its own body weight
and letting the wind caress it
into a dance with the air
and the courage to leave
that safe old cocoon
behind

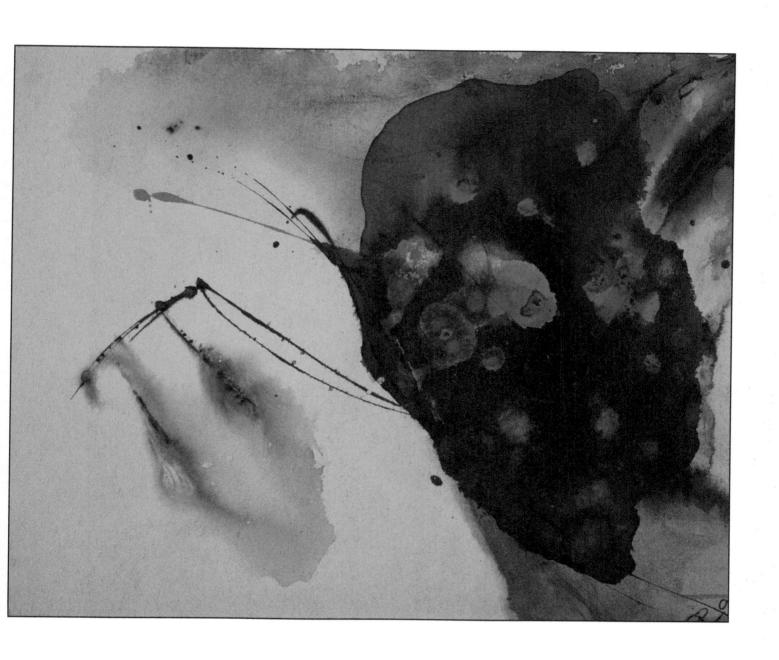

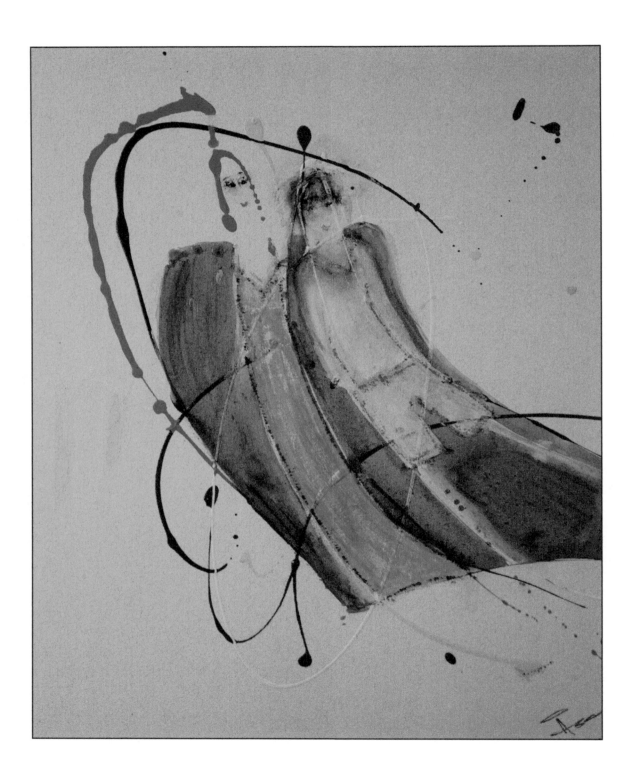

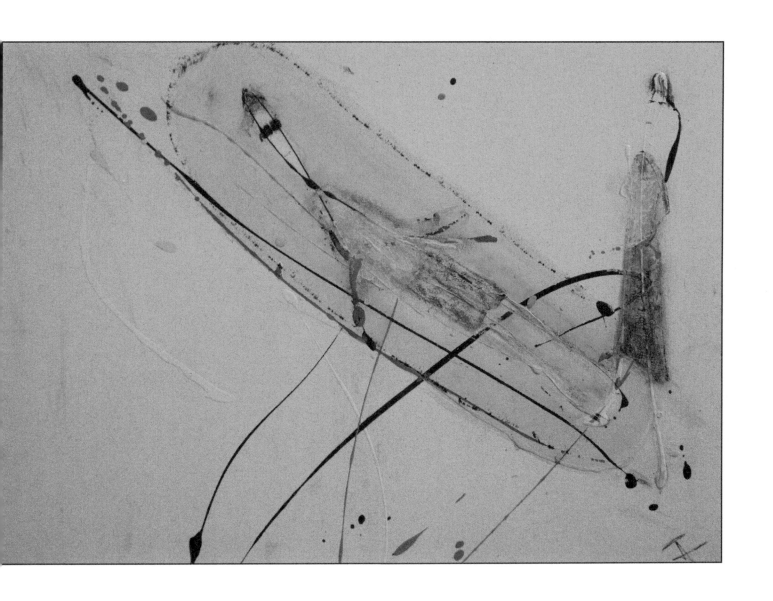

Absolutely nothing
did they have to talk about
and they did that a lot
talked about nothing

When there were all those other things
where their words couldn't reach
words hidden in deep dark forests
words riding on the rainbow beyond the mind
words never spoken
by them
too busy
talking
about nothing

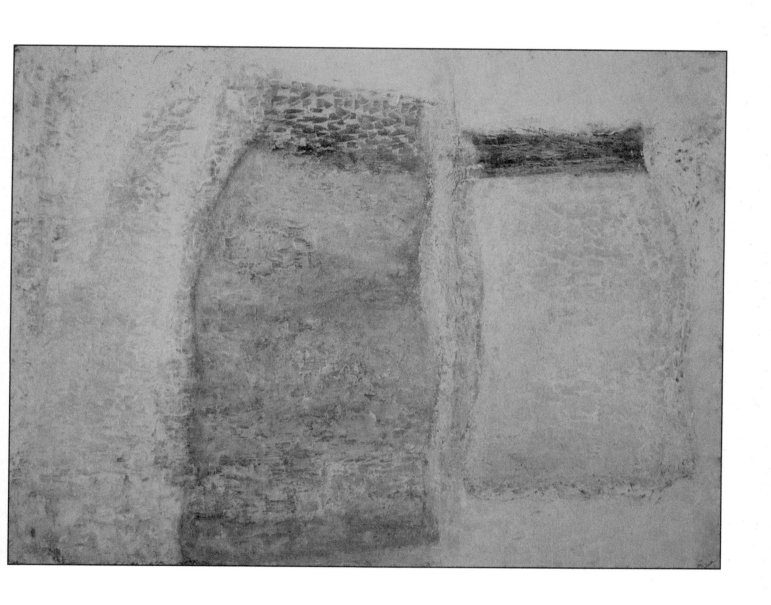

She was so busy
collecting the sunshine
of yesterday
she totally missed
the new morning sun
and when she was finished
the sun was gone
and she cried in her pillow
all night

I never understood her
but I loved her
as children do
love their mothers
even though they keep us up
all night
and then they fall asleep
just in time
for the morning sun
and a new day
is wasted

But one night I collected
her tears
and thread them upon a golden string
and I woke her up
in the morning

With my necklace on
she faced the sun
and for the first time
I saw her smiling
and her necklace turned into rainbows
that kept carrying me
through that day
and many others

They sometimes give that to us
memories of rainbow pearls
to wear as memories
of our loving mothers

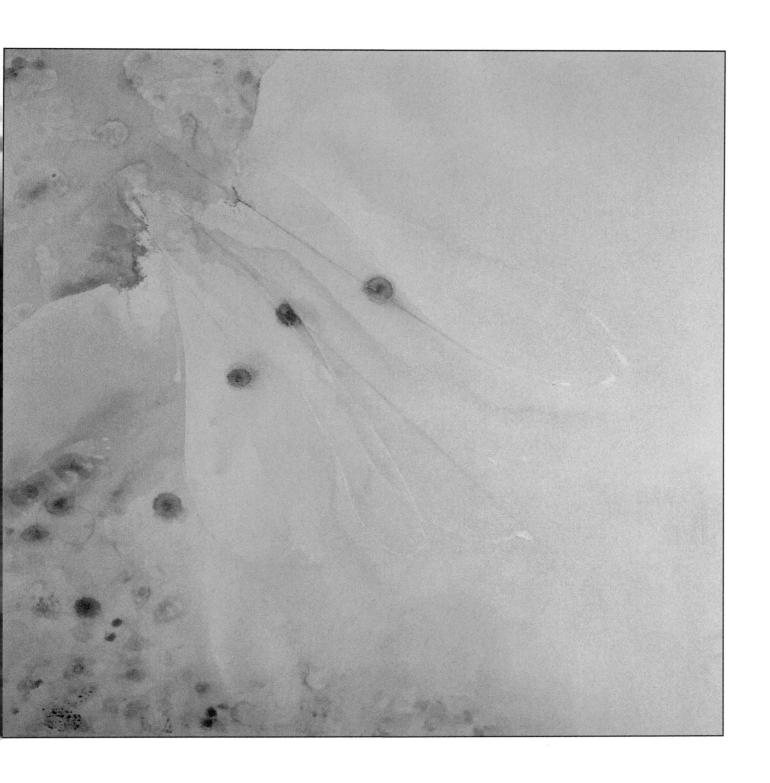

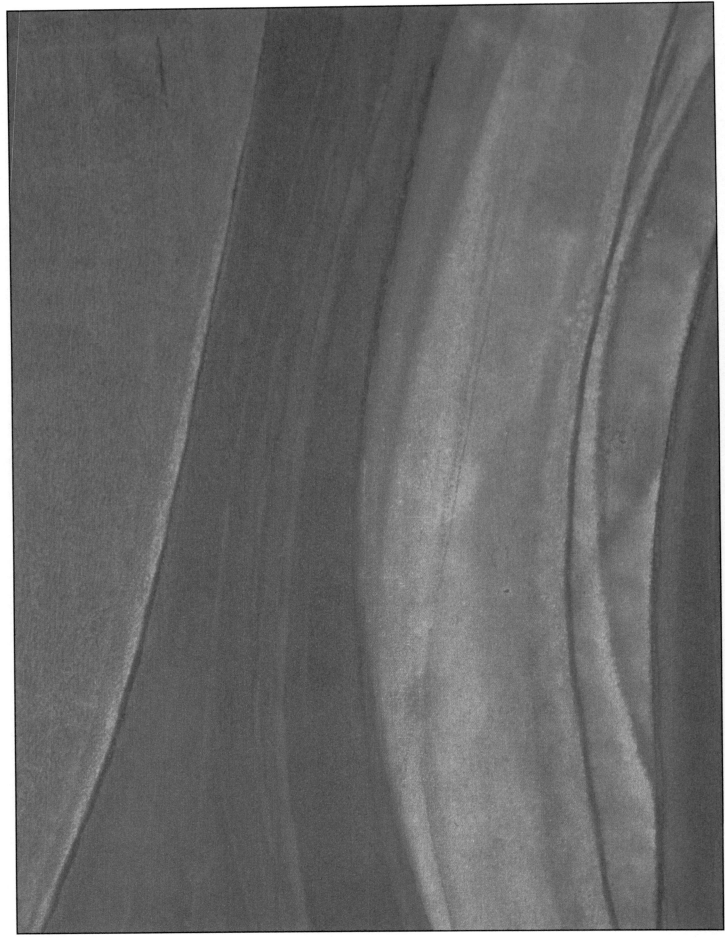

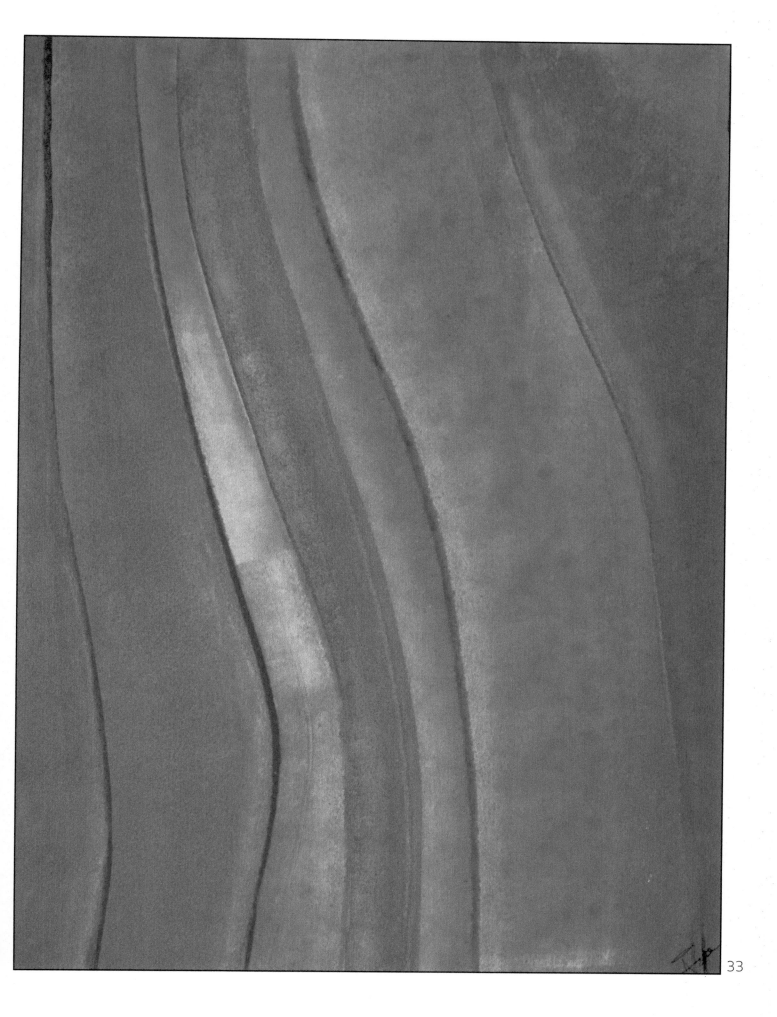

33

Millions of times
has it happened
before
millions of times
have people fallen in love
and kept reaching out for something
to prevent them from falling

And nothing is there
to protect us
from love

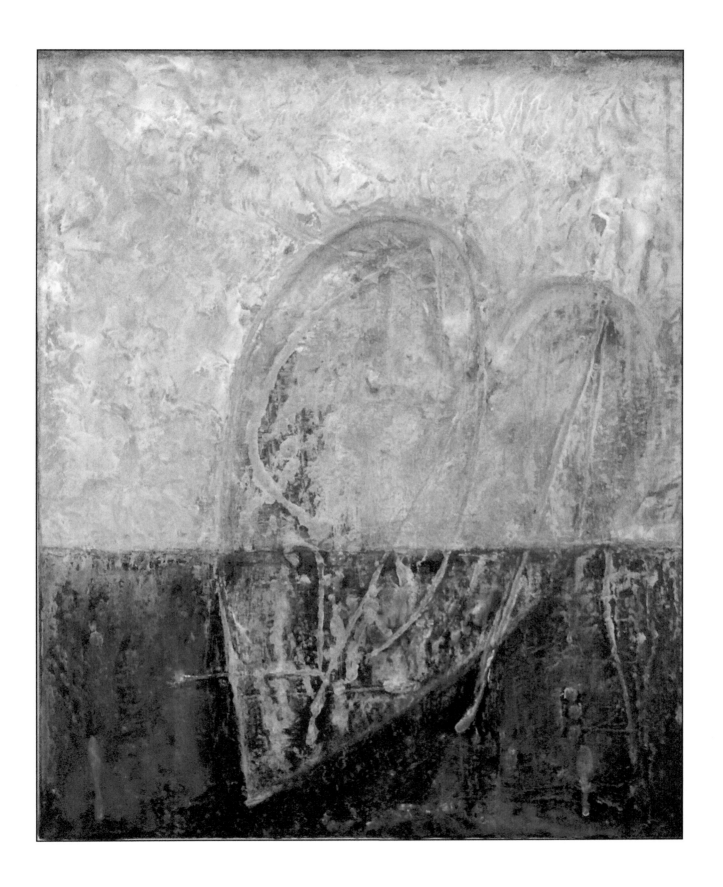

Constantly
hovering over my life
my longing desire
like a colorful peacock
is spreading its impressive feathery tail
like a grand illusion
just a little out of reach
but always there to pull me out of my reality
of gray pigeons begging for breadcrumbs
on Piccadilly Square

One rainy day waiting for Sarah
who was late
the storm grabbed my old umbrella
and broke it
so I was drenched by the heavy rain
and my new shoes totally flooded
ruined for life
and
you came up and offered me the protection
of your colorful umbrella
that you gently opened up over my soaking head
like a peacock opening up its tail
and we laughed into the rain
my mouth filling up with raindrops and joy
and sweet expectations of another kind of peacocks
that actually could lift from the ground
and take me with you
away from all these gray pigeons
and rain
on Piccadilly Square

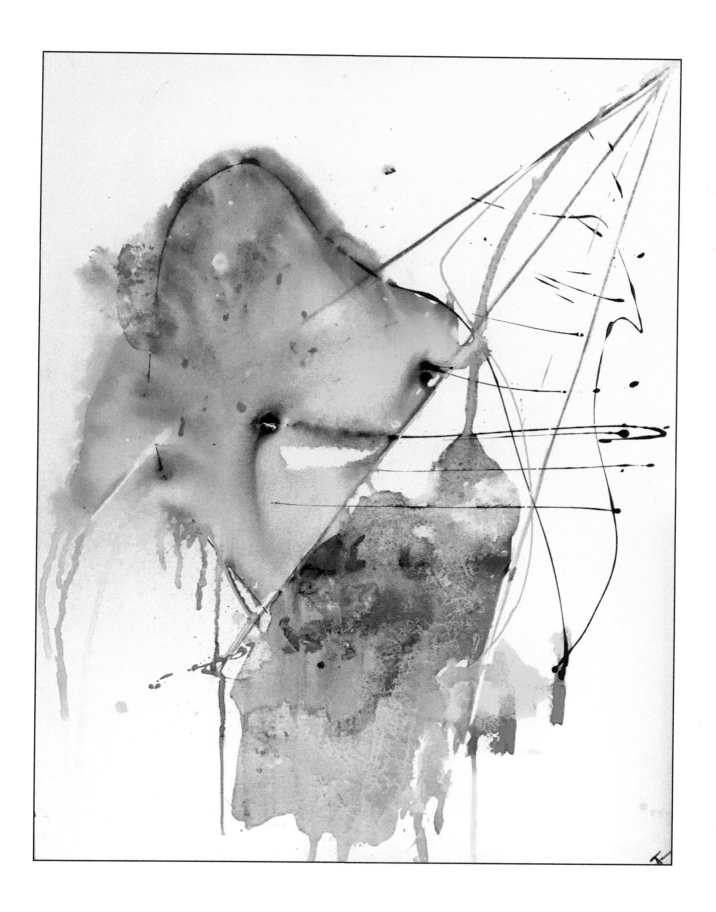

I looked up in his face
maybe tomorrow everything will be alright
maybe tomorrow the memory will be as hard for me to read
as the old newspaper that has laid in the sun too long
the paper brittle and the letters faded
the pictures all blurry
and no one really cares
about the once-big news

Maybe tomorrow everything will be alright

But today it still hurts
the pain is like a dentist drilling through my heart
to clean out the cavity
caused by too much of something I thought was so good
that tasted so sweet
at the time

Who was I to know that it caused my heart to break?
There are no dentists who can put a filling in your heart
to make it stronger and not fall apart
but there is a kind of root canal
you have to put it in yourself
without anesthetics
so it still kind of hurts
but it does makes you heal
they call it forgiveness

And tomorrow everything will be alright

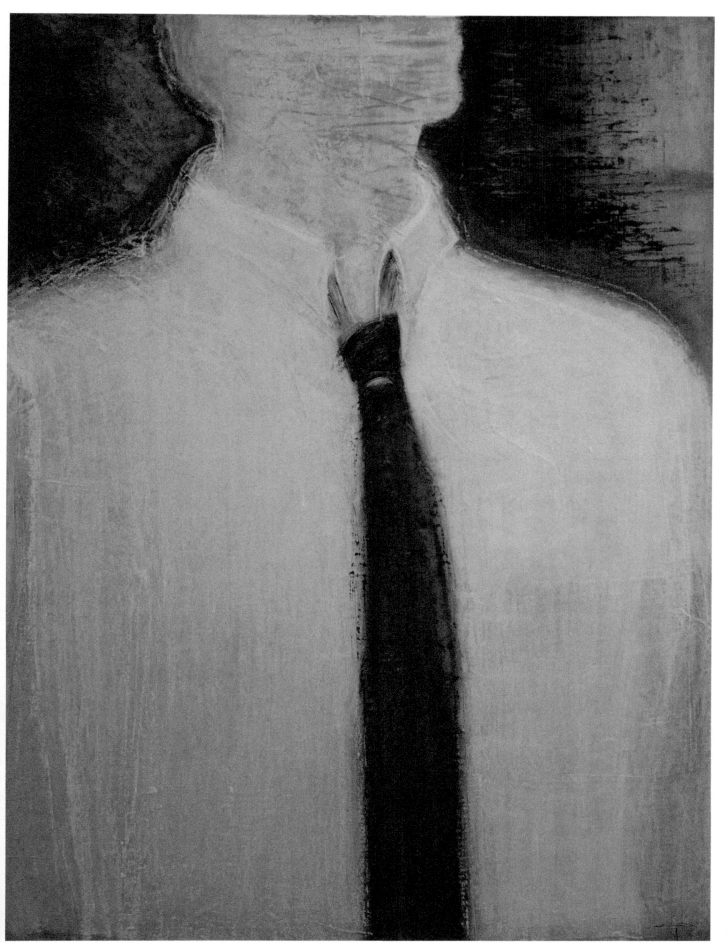

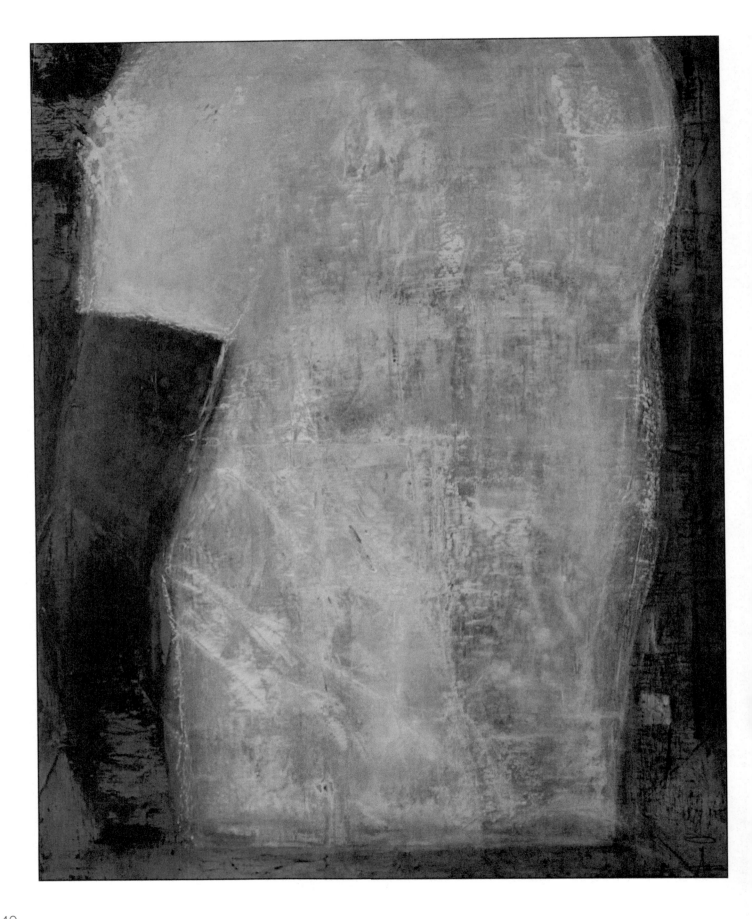

40

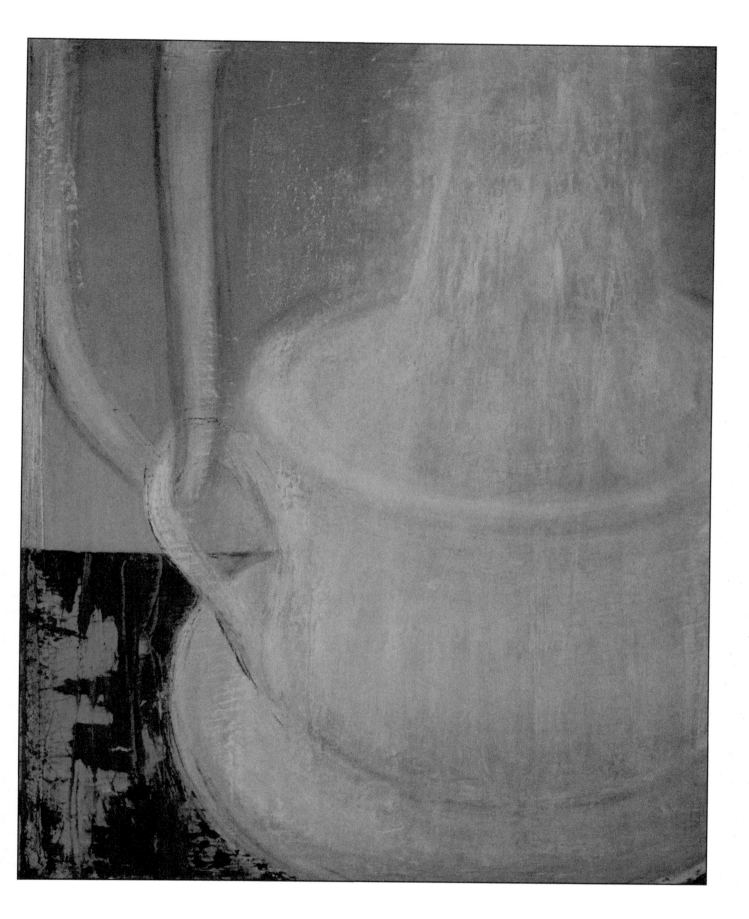

Money is a hard thing
like silver or gold

Money is a bad thing
like bribes or stolen savings

Money is a sweet thing
creating freedom, gifts and possibilities

Money is everything
when you do not have it

Money is nothing
when your loved one has left you

Money is a funny thing
when you leave this world behind
and all your money stays
smiling at you
from behind your back

Money is a hard thing

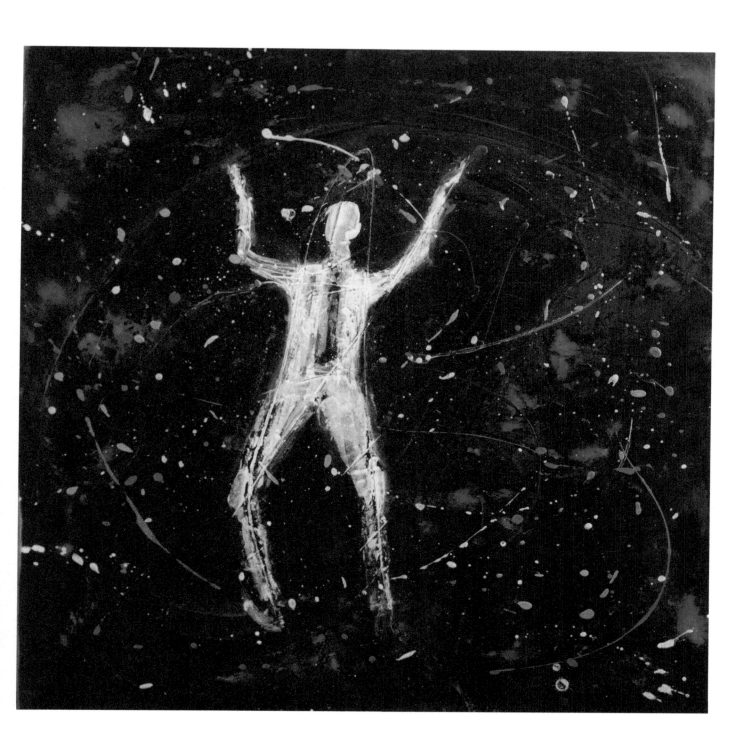

Next time
I will not
sell any tickets
to the performance of my life
I will just do it
the very best I can
and no one will watch
and when the curtain goes down
I will bow
and thank the empty audience
for the applause
they never gave me
and then go home
and write my own critiques
before I read them in the newspaper
and share a bottle of champagne with Fame
and thank her for the time we once had together

Then she would leave me
for another

I loved you so
my very own
Fame

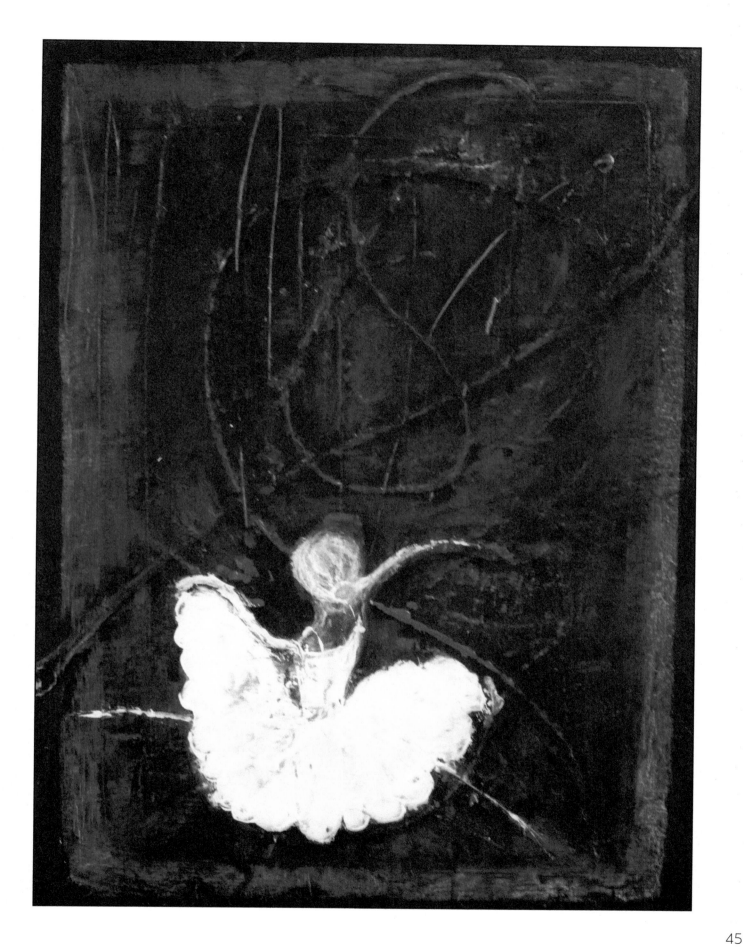

I'm an addict

One letter led to another
all of a sudden
I was in the middle of a word
and the sentence was finished
before I knew it

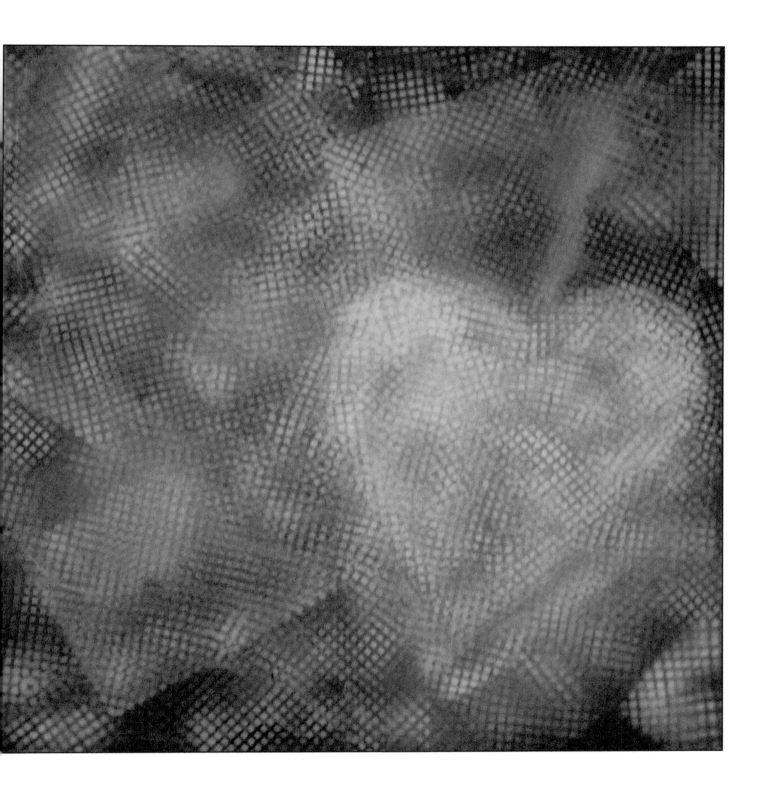

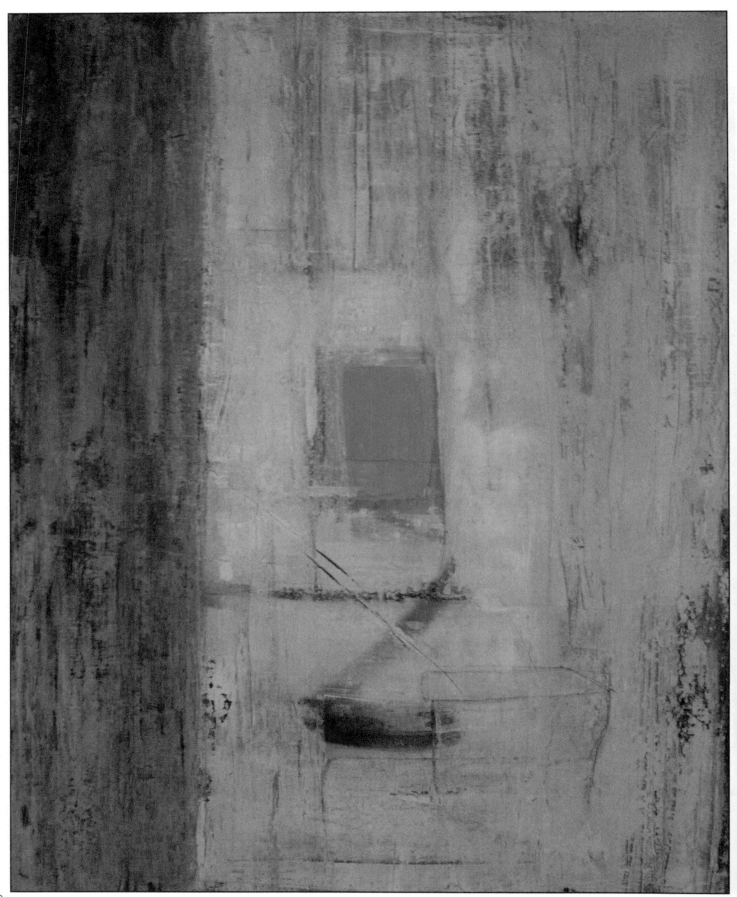

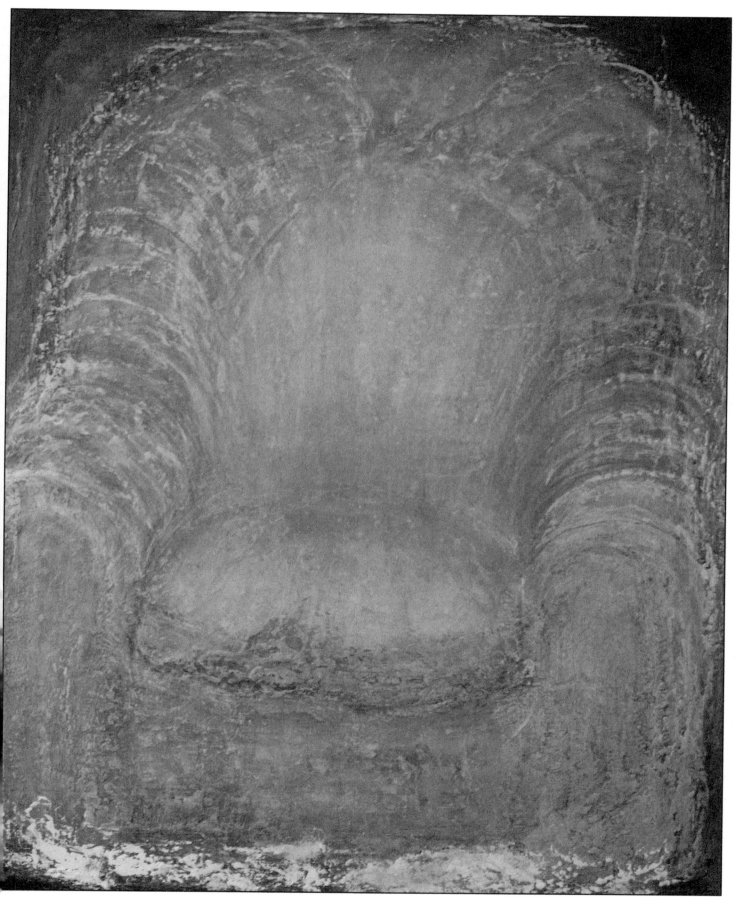

U as in U and me
U as in umbrella
to sit under together
with a friend
sheltered from the rain
warming each other's bodies
with wet arms
around each other's shoulders
U as in unanimous
and united in our understanding
for the process
of letting go

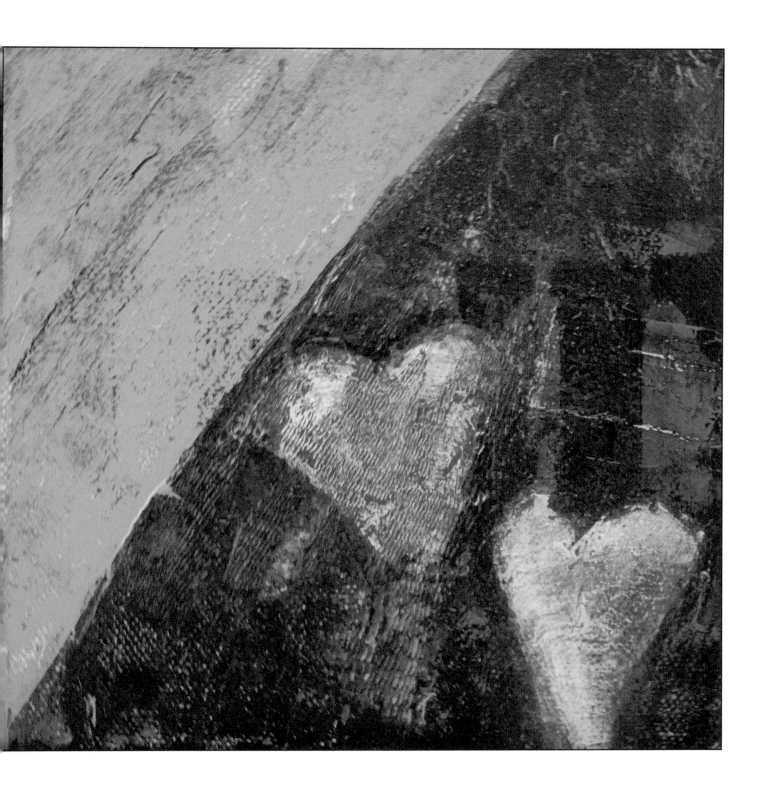

Life wakes me up
and gives me a poem
that makes me kind of worried
you know

Like your mother
when you didn't come home
that night
because of that boy you met
that kissed you so hard
your lips were swollen
the next day in school
and had hands
that could play on your awakening body
as if you were an instrument
that he needed to tune

Life wrote me a melody
to go with that poem
you know
and she gave me the notes

I had thought
we were all
just making up our own music
but I learned it was already written
by a composer
unknown to man

And no one is missing the concert
even if some of us
just have one single tone
to play
once

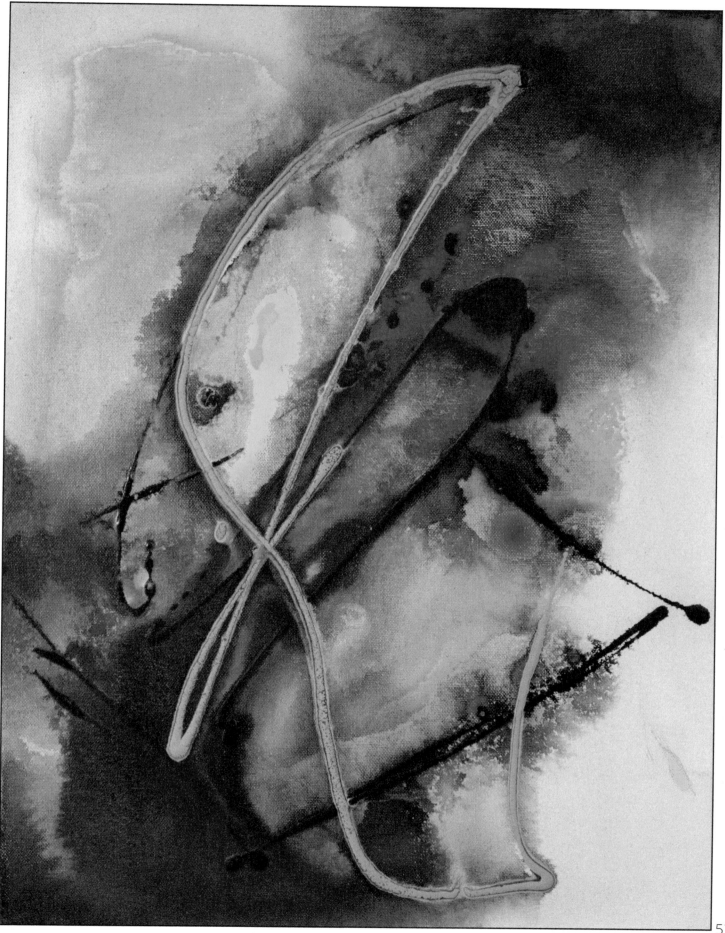

Never say no to a beggar
she just might be you
in another existence
standing with her hand
reaching out
for your mercy
giving you a chance
to show compassion

And you give her nothing
to take with her
into this life of yours

And then you wonder why
you have nothing
but emptiness
inside...

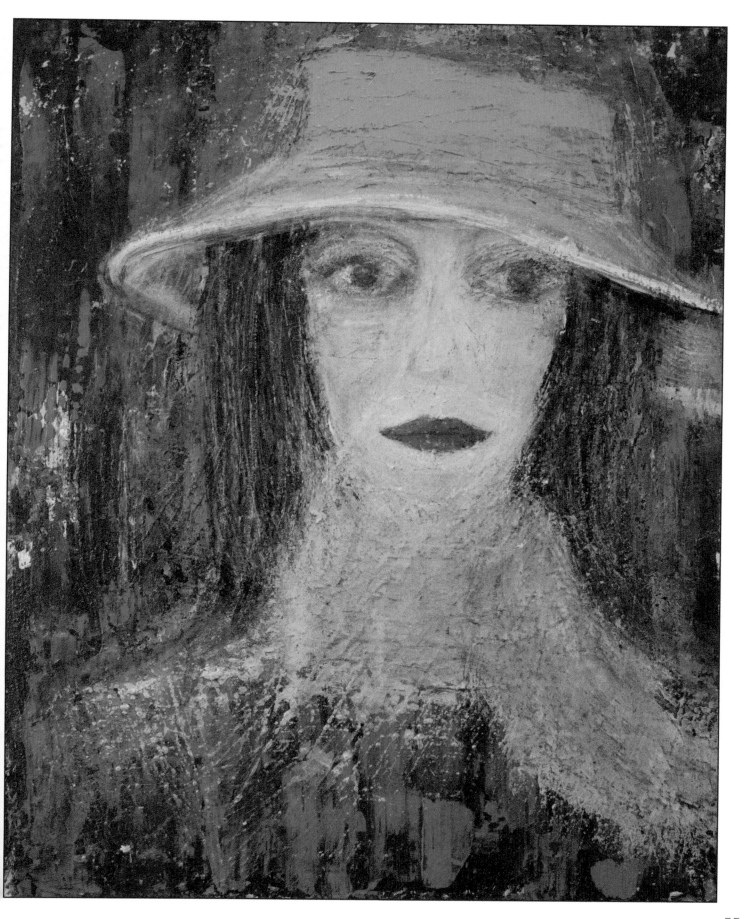

What do people do
who can take a shower
without moving three plastic ducks, a shipwreck
and hurting their toe on a broken horse
on the floor?

What do people do
who can sleep all night
in their own bed
without four other legs
kicking them and taking their blanket
and falling on the floor?

What do people do
who can eat their meals
siting in calm and quiet
without running around getting things
and drying up spilled milk
and racing out to buy the right kind of ketchup?

What do people do
who can talk on the phone
without someone screaming when his brother tries to cut his hair
in a new kind of style
or paint his teddy bear green?

What do people do
who can go a whole life
without any sticky fingers stroking their tired cheeks
and chubby arms hugging them
with big trusting eyes filled with that wonder
that tells them that they are the best
in the whole and wide world...

What do people do??

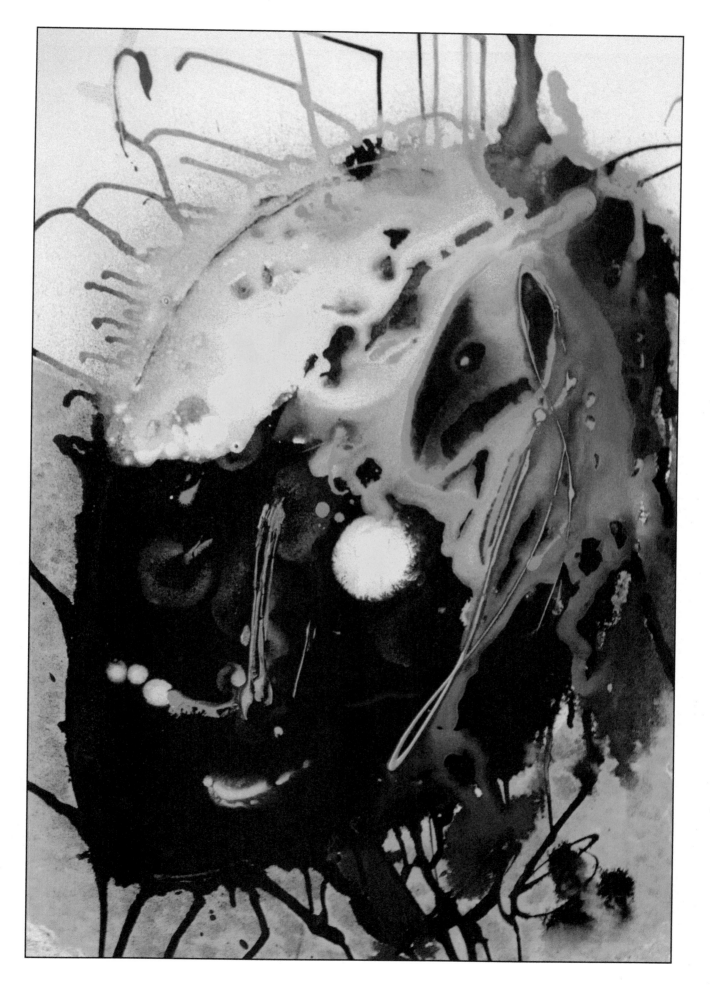

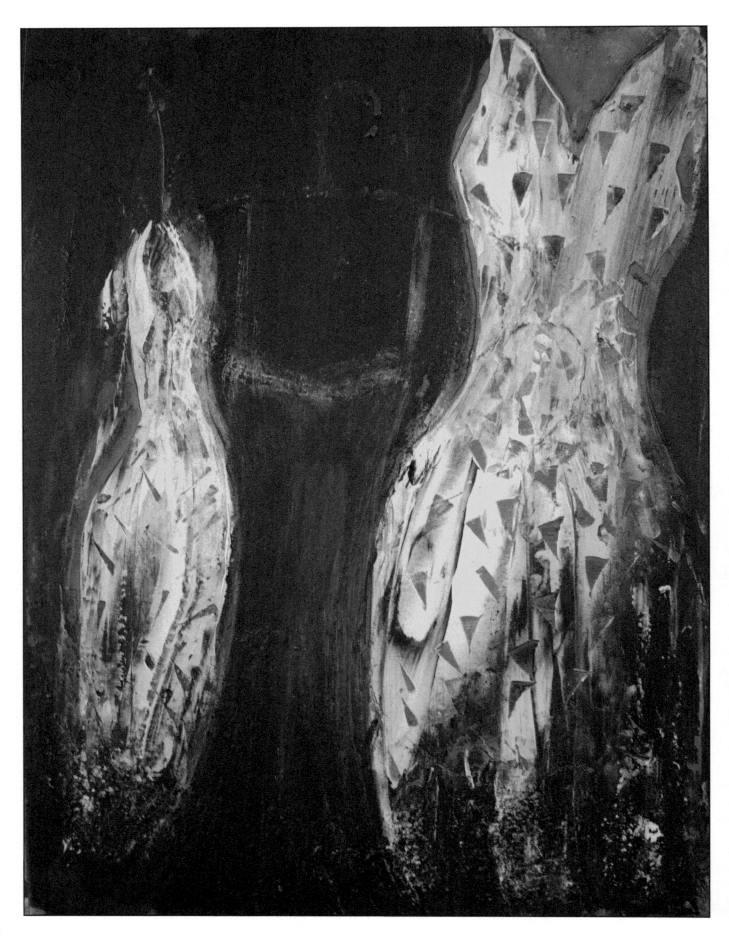

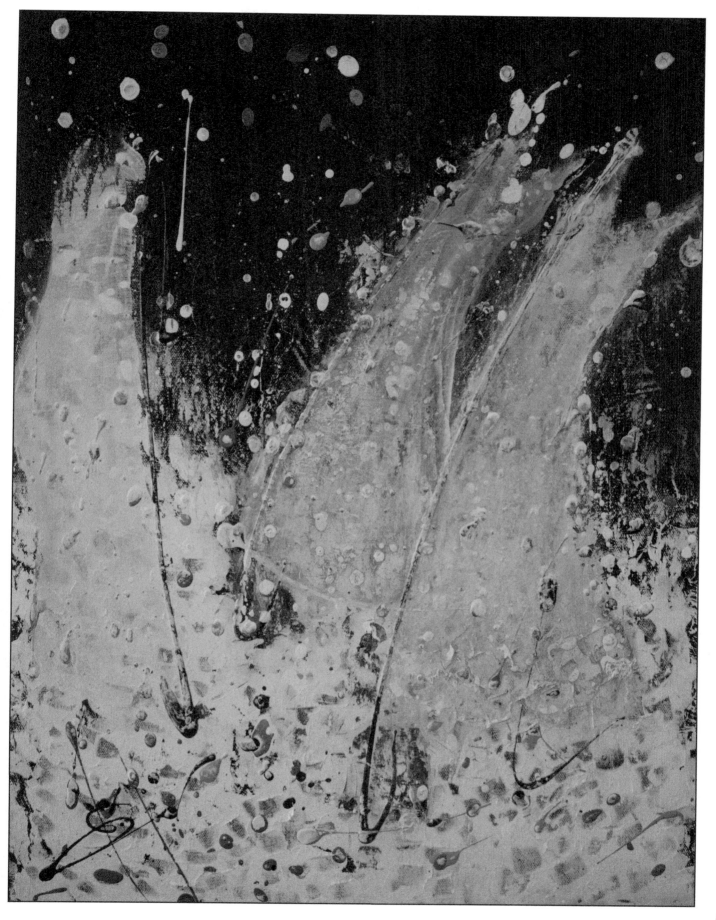

A man and a woman
like different sides of a zipper
both sides full of angry teeth
all those tiny things
that need to perfectly fit together
before the loving zipper lines them up
and makes them
into one

Thank God for buttons!

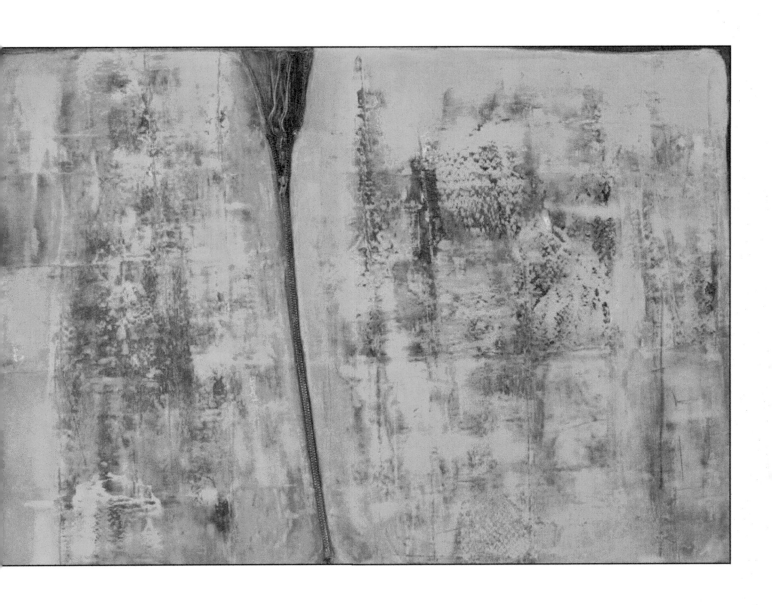

Too close to me
you came too close to me
you touched those parts of me
I didn't want you to see

Too close to me
you stepped too close to me
I have to make me free
to never see you again
never

When I say never
I mean for ever
and ever

Too close to me
life came too close to me
when I met you

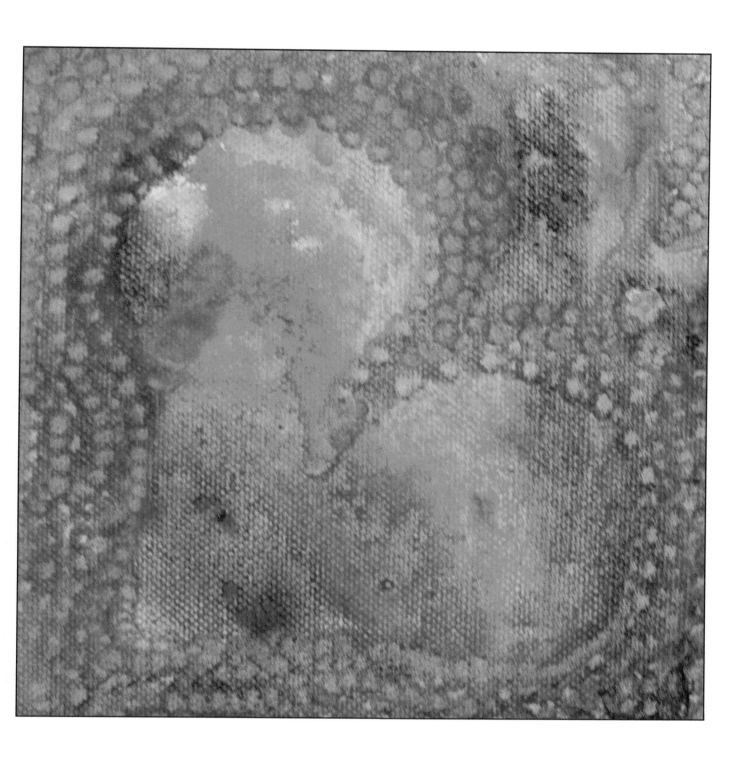

An orange morning...

A barn a girl and a horse
a field some grass and a sun
a morning an orange and a smile

A boy on a road on a bike
a smile on a face and a hi
a beginning a hope and a laugh

An orange
that never got eaten

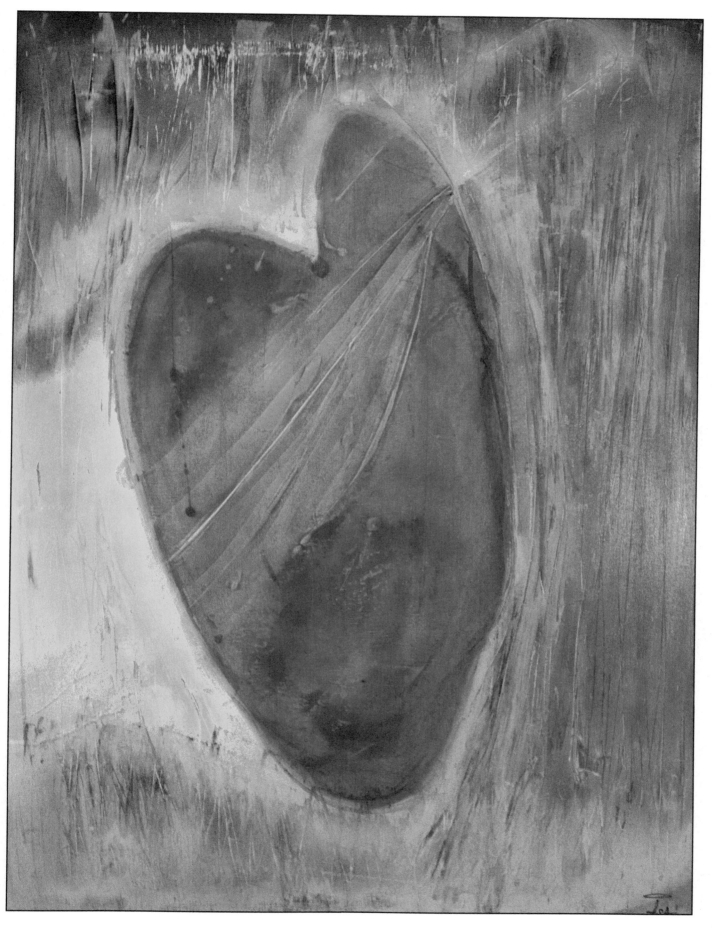

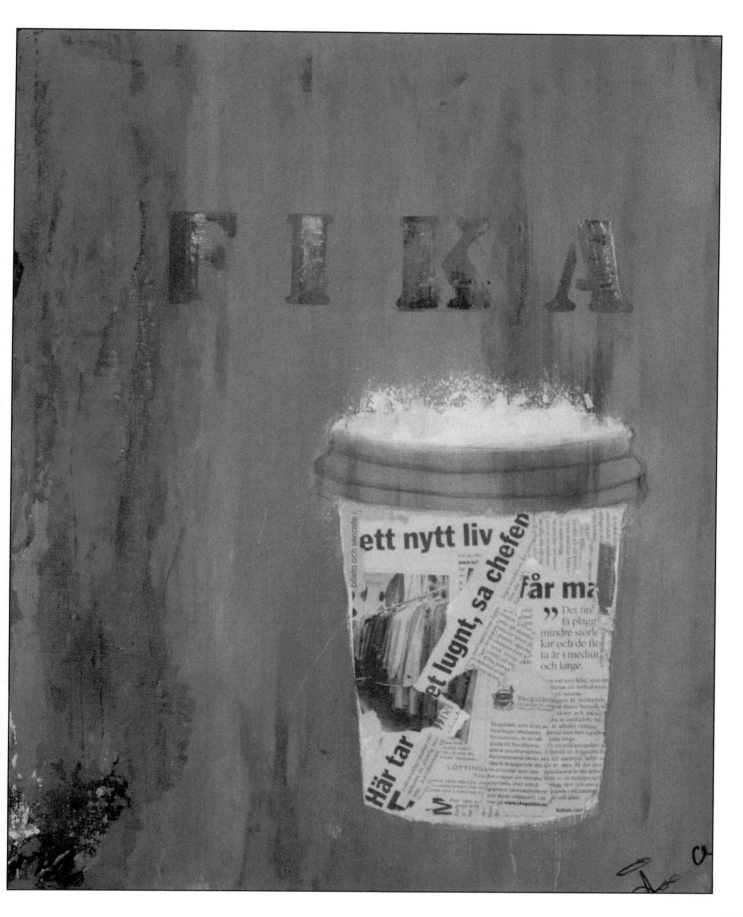

How do you explain
the endless ocean for a goldfish in a bowl
or fishes in an aquarium
or love for someone
who wonders
if there possibly

is an app for it?

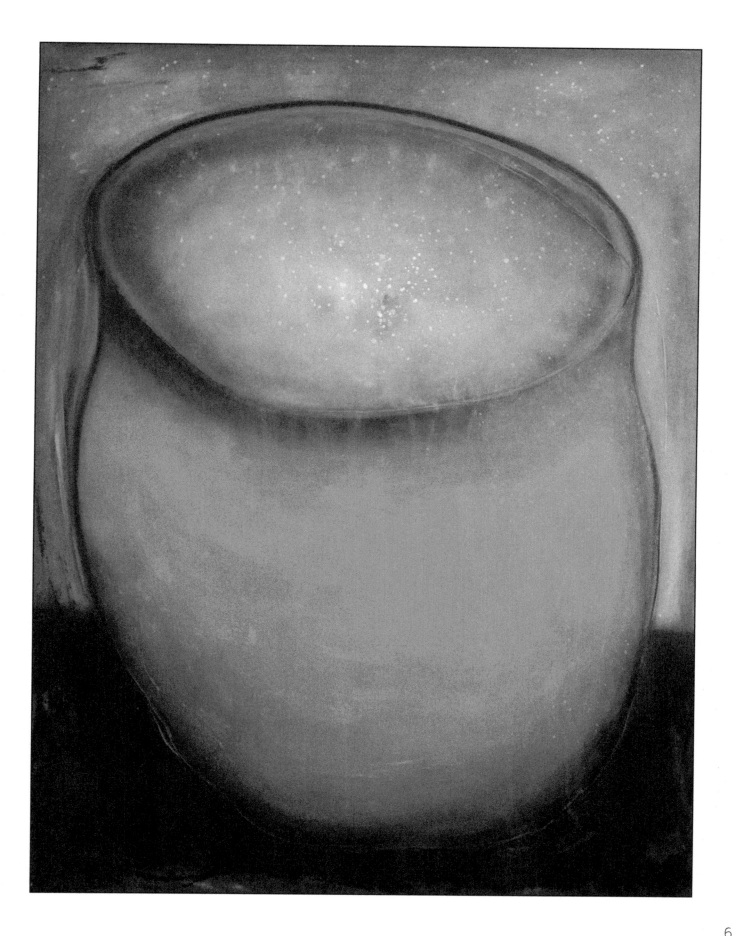

He was strong
exciting
and hot
just like my coffee

Unfortunately
he cooled off just as fast

Red snow is falling down
like fire flakes
covering the earth with fire
rivers of fire
fire forests

We all reach out to each other
to help
to survive
and our hearts catch fire

And God makes a secret wish for each one
and like candles on a birthday cake
he blows us out

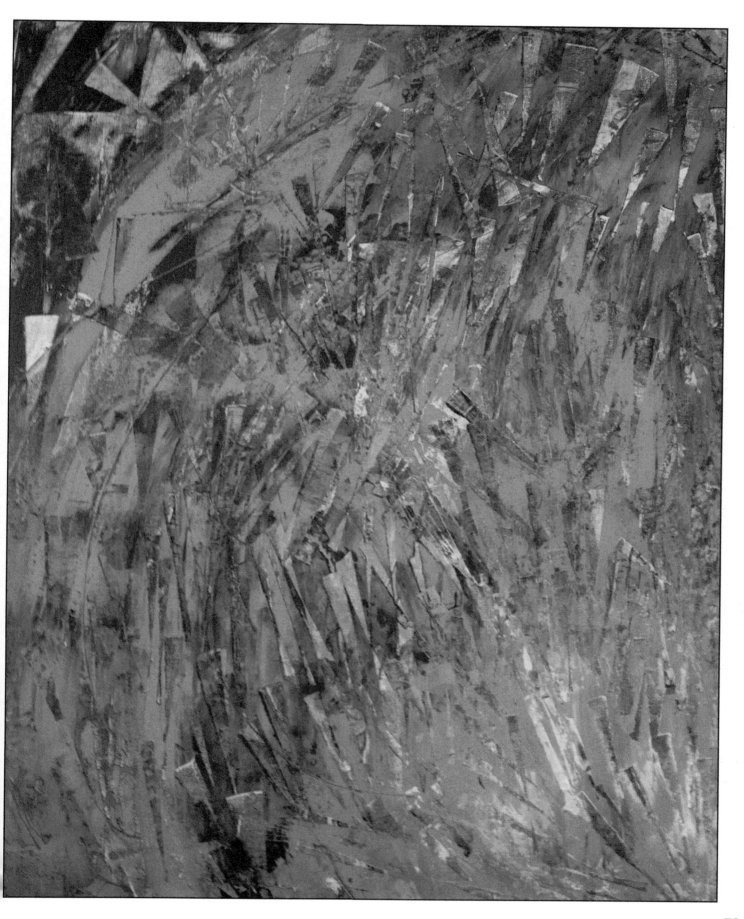

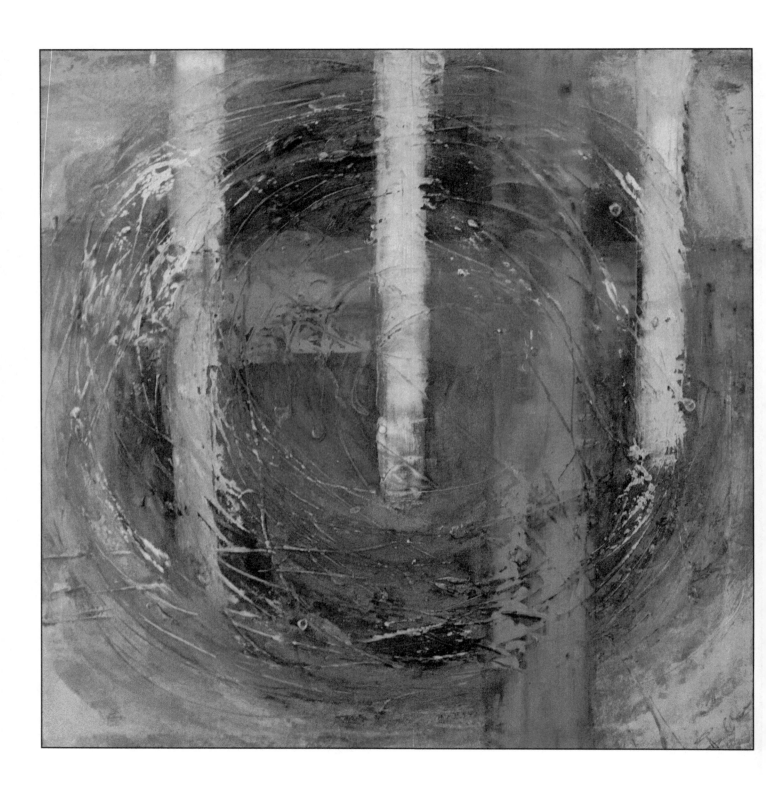

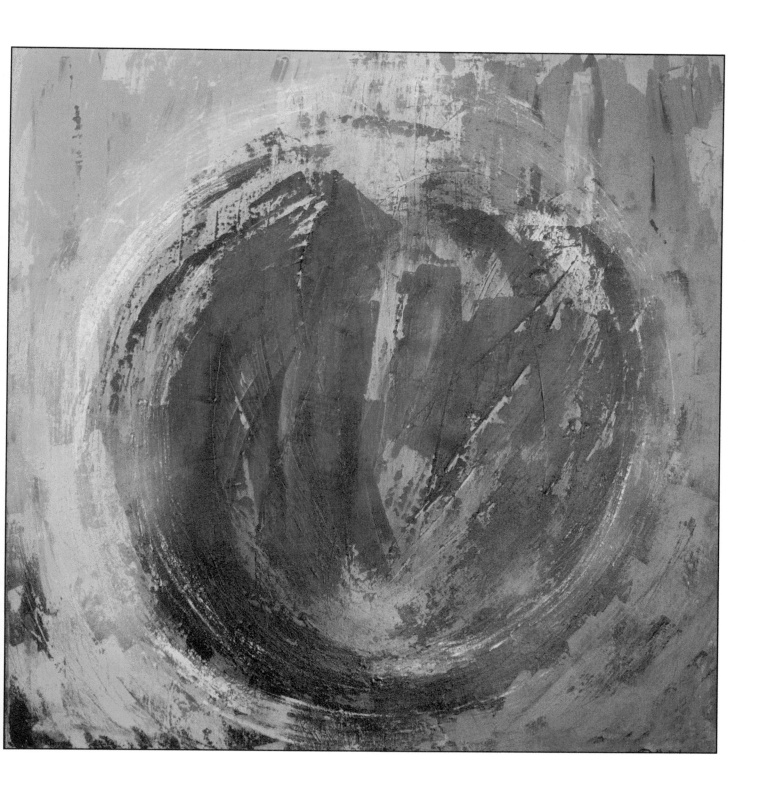

I clean the cabinets
creating order
in all the mess
no more piles on the floor
but neatly folded towels
tucked away with all the clothes
hanging in disciplined order
in my closet
sprinkled with raindrops
falling down my cheeks
tasting like spring

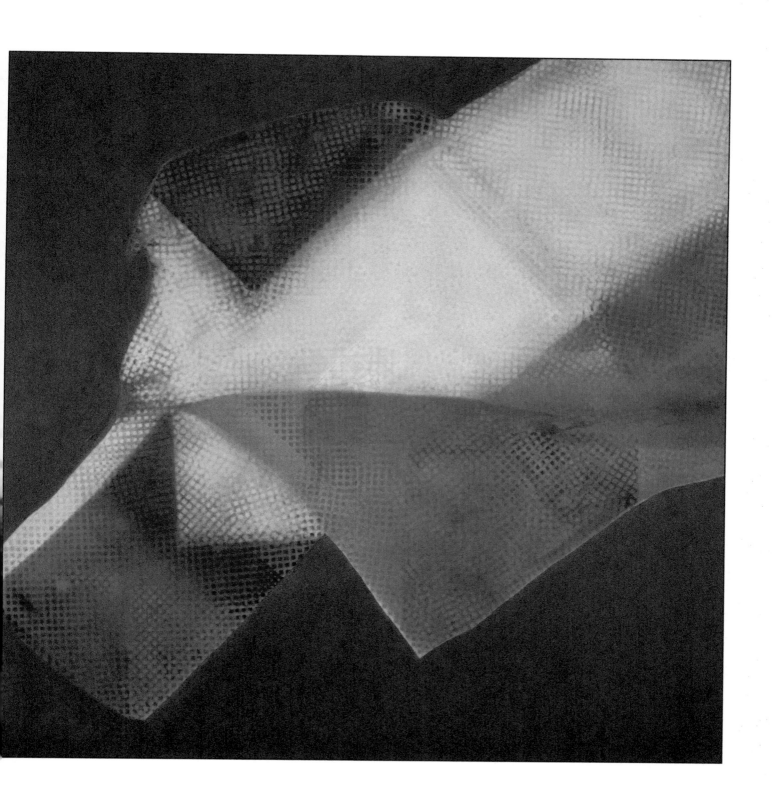

Possibly nothing
of value
did she have to add
to his life
so why then
when she left
did it feel so empty?

Did she steal his air
or hope, faith and beliefs
or his happiness
about being alive?

She was the one
he wanted to give it all to
but instead she just took it
and left.

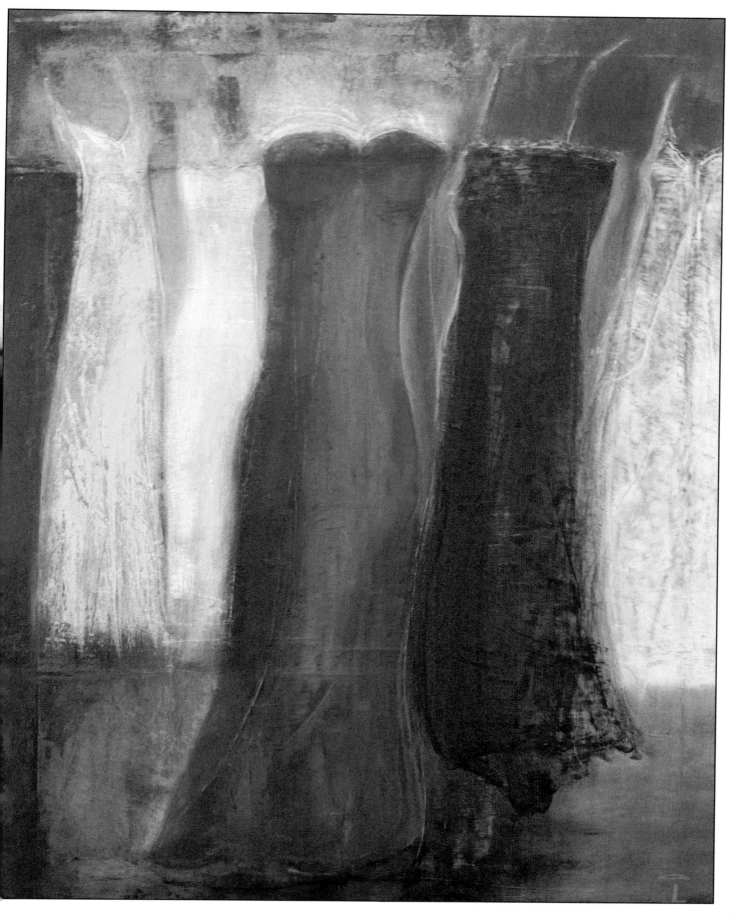

Separate beds
Separate minds
Separate hearts
but they shared their bathroom

No one looked in the mirror
to see what had happened

When they cried
they cried separate tears
that were dried
by the pillow
and not by another loving hand

And no one looked in the mirror
to face the pain

A child came to them
and froze in their home
he ran around looking for joy
he looked in every corner

Finally he smiled
they knew he had found it

They asked him where

"I looked in the mirror"

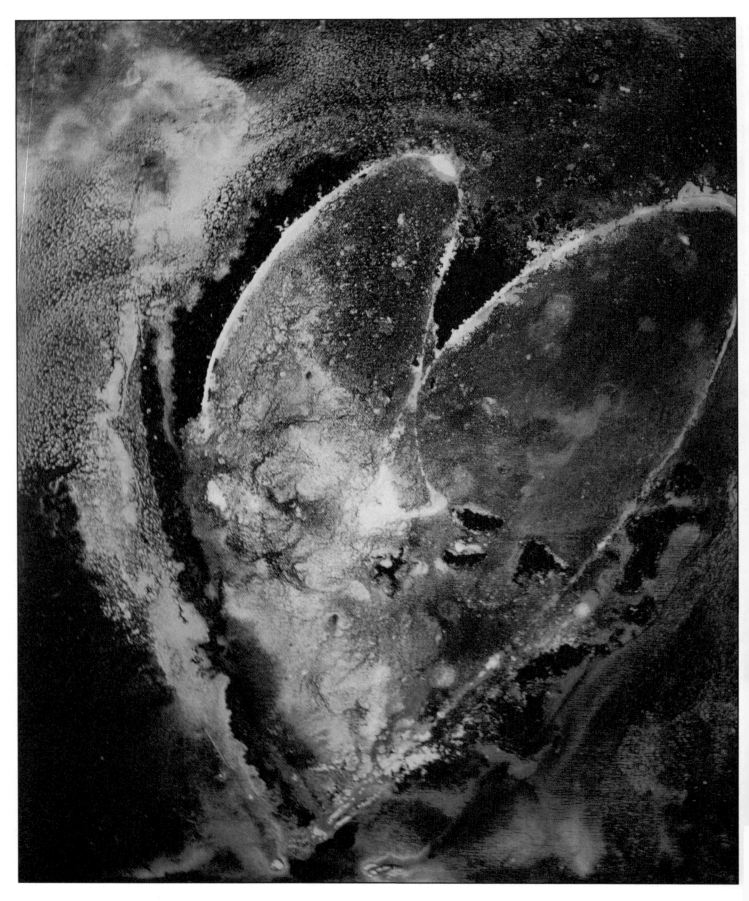

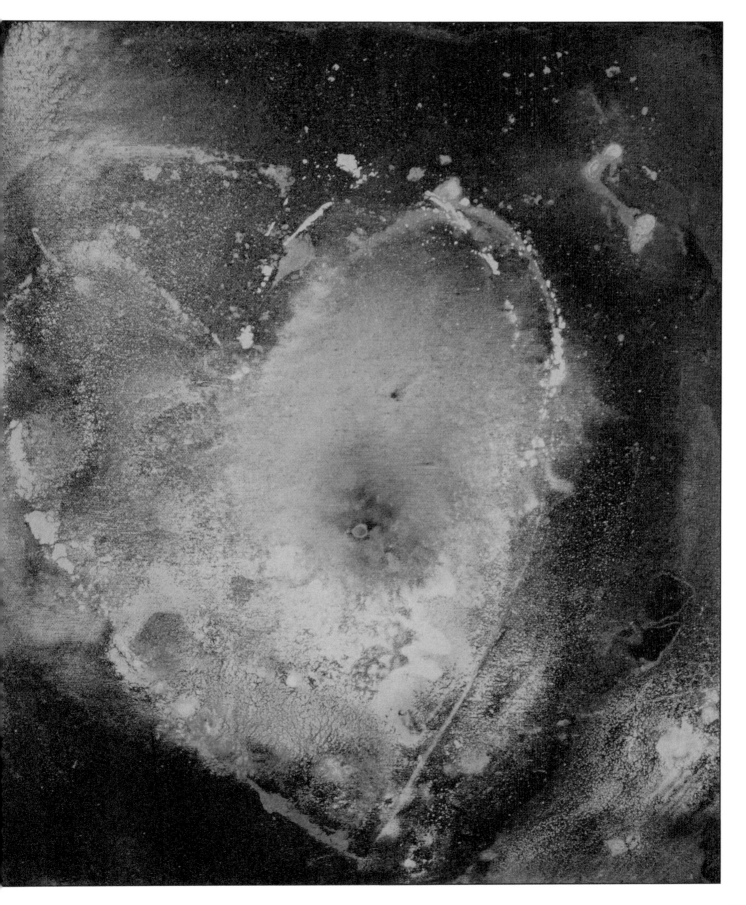

83

Coming at me — stronger
every time at night
is that dream of forgotten leaves
from that tree

 that died

Coming at me — stronger
every day at dawn
are those shells
in silent waves
filled with sound
from an ocean

 no longer here

Coming at me — stronger
every day I live
is that yearning
for fading memories filled with purple
from a place

 I never went

But my footprints
are leading me back ahead

 of time

Coming at me — closer
 is the end of time

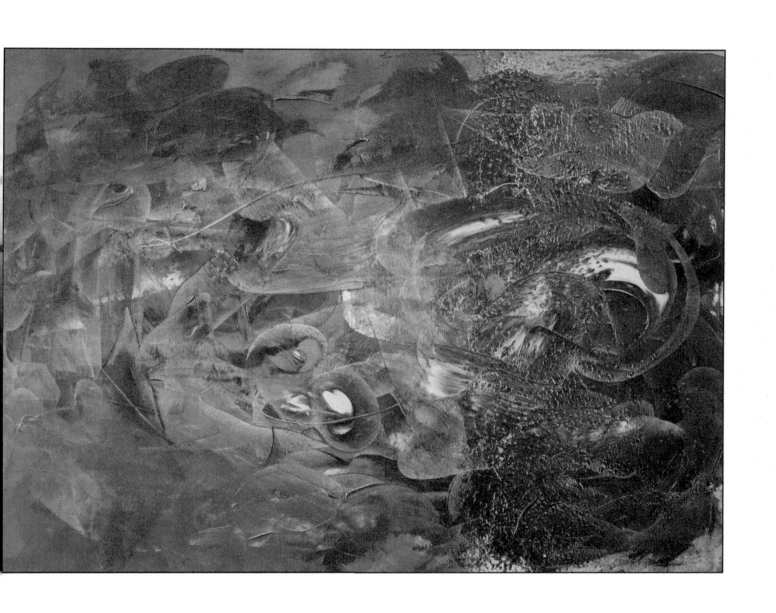

Closer than ever
you follow my steps
the slower the deeper
my footprints
are leaving you
behind
but close to a future
we run
not feeling
the rain
that we are laughing into our mouths
and our footprints
are slowly
washed away
our past is vanishing
and there is nothing
to follow
and prevent us
from being naked
and free...

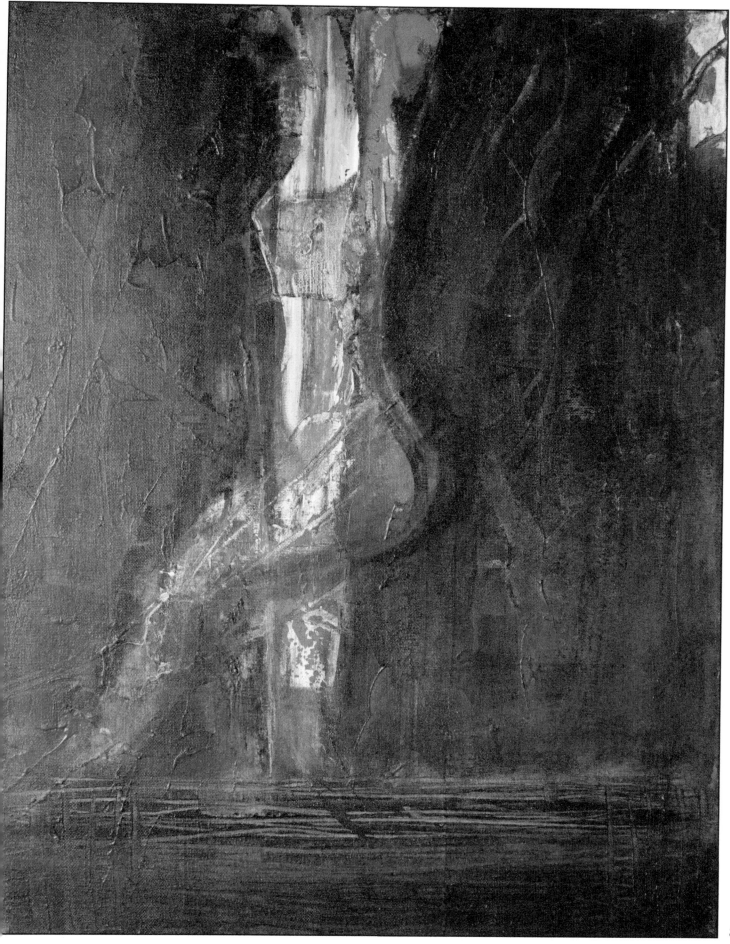

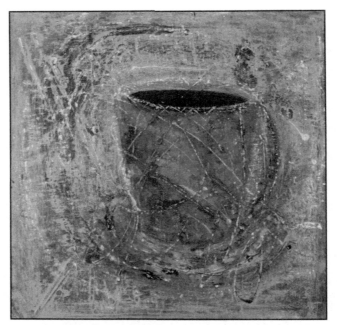

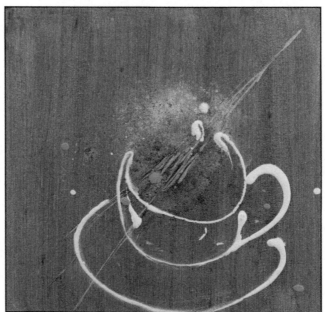

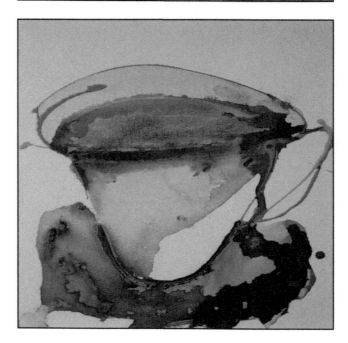

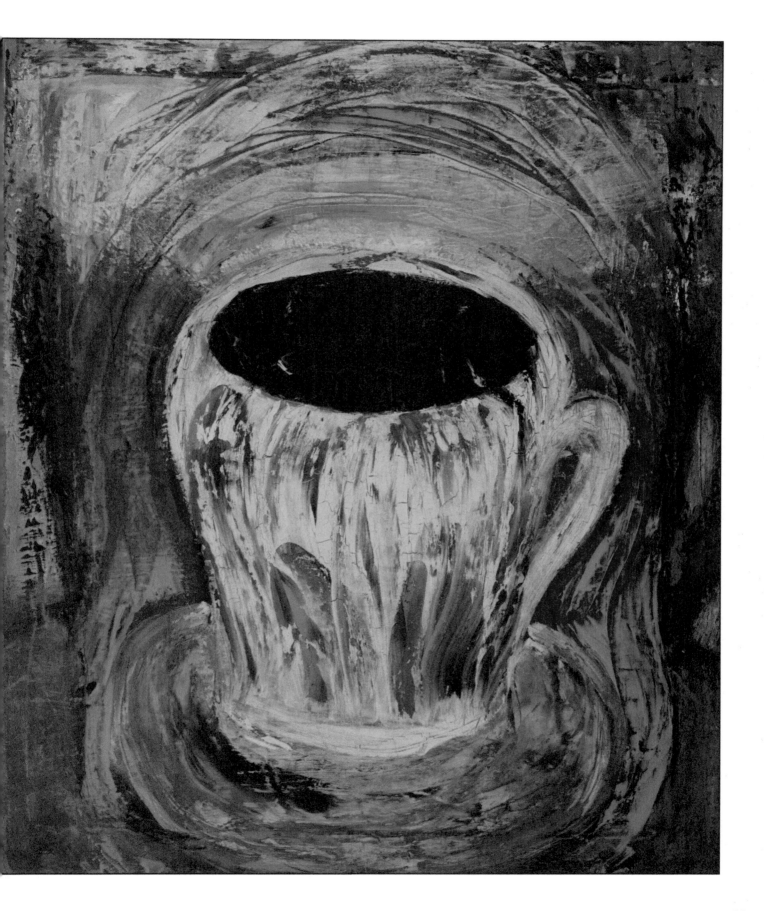

Raindrops, sunrays, pearls of dew
nature is filling the air
with fragrances and colors
shapes and shadows
sounds too subtle
for humans to perceive

We can see a blueberry
but not sense its essence
taste its color
or feel its message...
we just eat it
not knowing how its color
adds to ours
its growth
its journey
now is becoming part of ours
flooding our system
with the green of the forest
the song of the birds
the moisture of the moss
and the evening fog
the quiet humming of mosquitoes
and the silver rays from the moon

Making you part of a forest
you never have seen
and never will walk in
but
the subtle life of a blueberry
is now also
part of yours

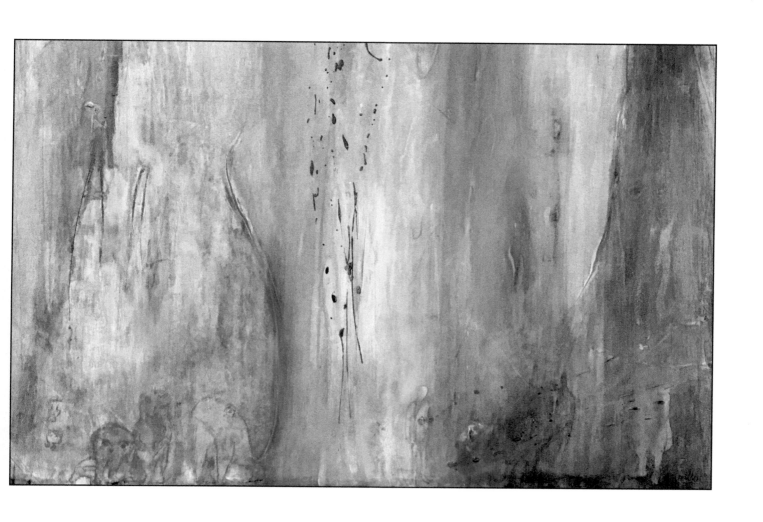

You naked woman
how do you let go
of your outer beauty
do you roll it off
like expensive stockings of silk

Or do you
like the topless sunbather
expose it all
without anything left
to protect yourself

Or are you hiding
scared
behind a pair of glasses
still wearing your make-up
of a perfect surface
when falling asleep at night
hoping
that no one can see
who you really are...

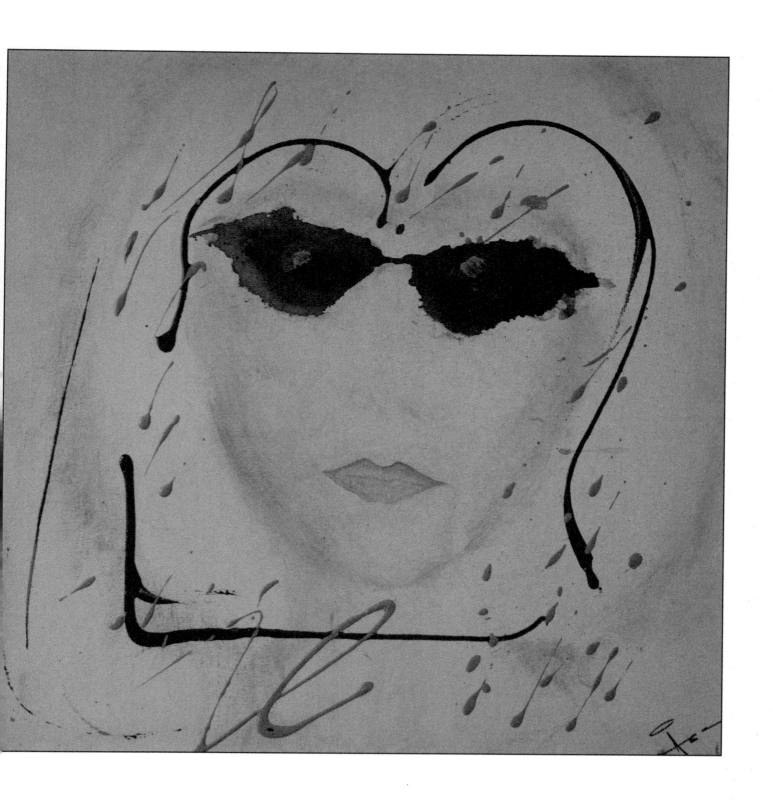

But please move slowly
when you come to me
my feelings are slow
and the waves you make
are drowning me
I'm losing the grip
I'm losing me

So please think slowly when you think of me
I don't think very much
of me
anymore

I like you to love me
deep in your heart
but please love me slowly
my heart is asleep
and is afraid of the deep

So please love me slowly
and help me to see
who you are seeing
when you look
at me

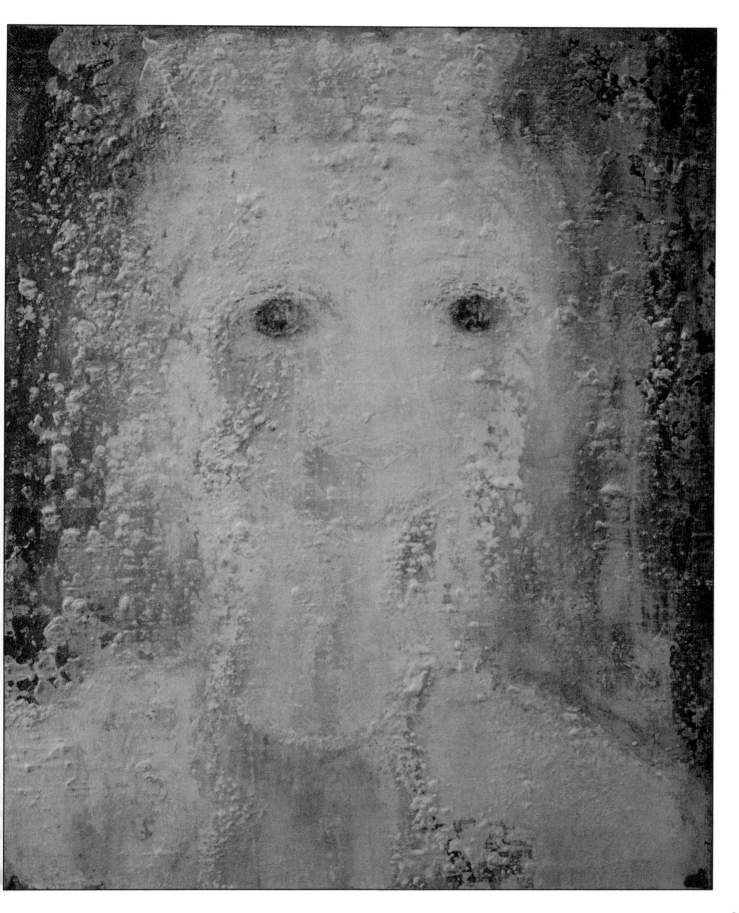

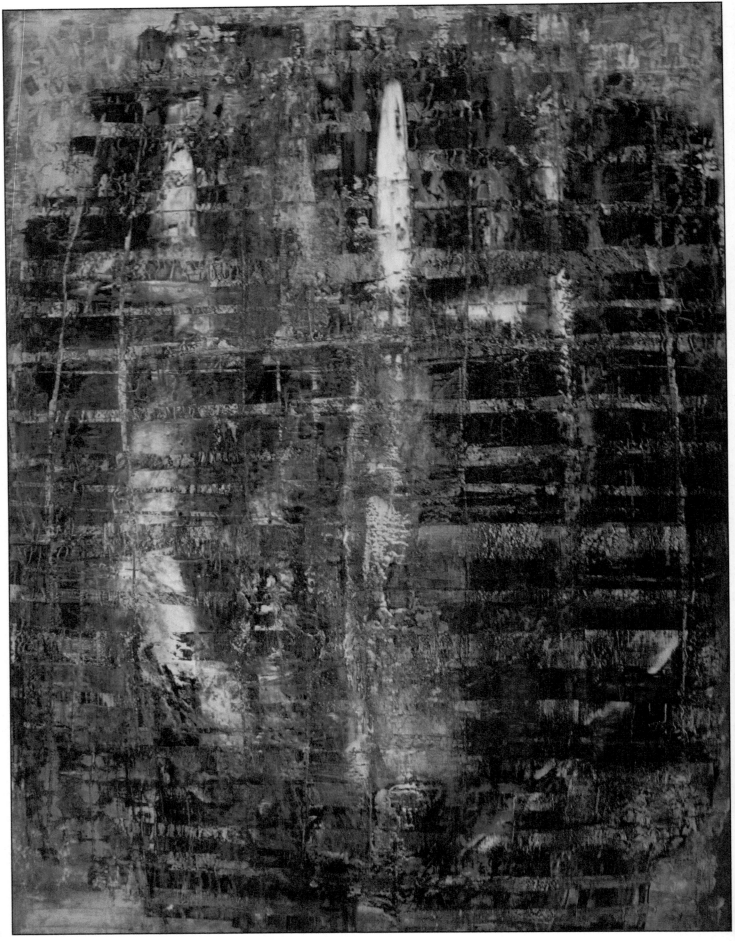

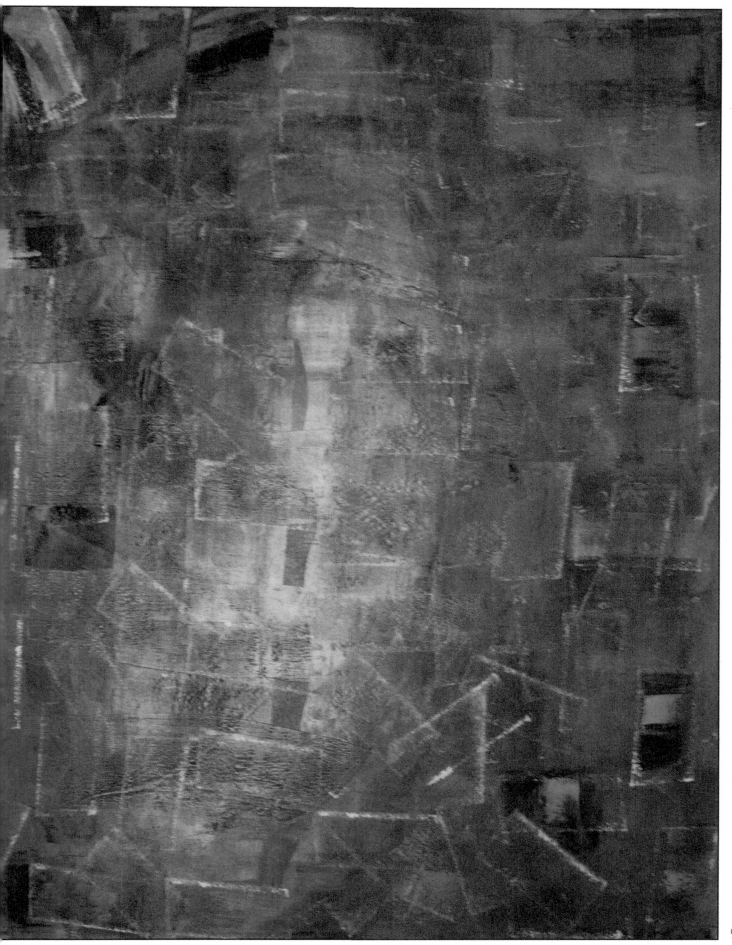

Three coins in my pocket
that was all I had
three coins for nothing
was the state of my fortune

When a man of no home
asked me for money
I gave him my three coins of nothing
he smiled and thanked me
for my generosity
my kindness
my loving

I looked at him

For him
my nothing
really was a fortune

We smiled
and parted
both carefully carrying
our gifts

Life was roller skating down the street
I tried to stop him
and ask him out for a romantic lunch
by the ocean

He smiled and waved at me
as he passed me by
his shorts looked kind of shiny
but he didn't stop
to take me for a ride
he was eating
a small French fries
a big mac and a coke

And I still stand here
looking
very hungry for life
to turn my corner
again

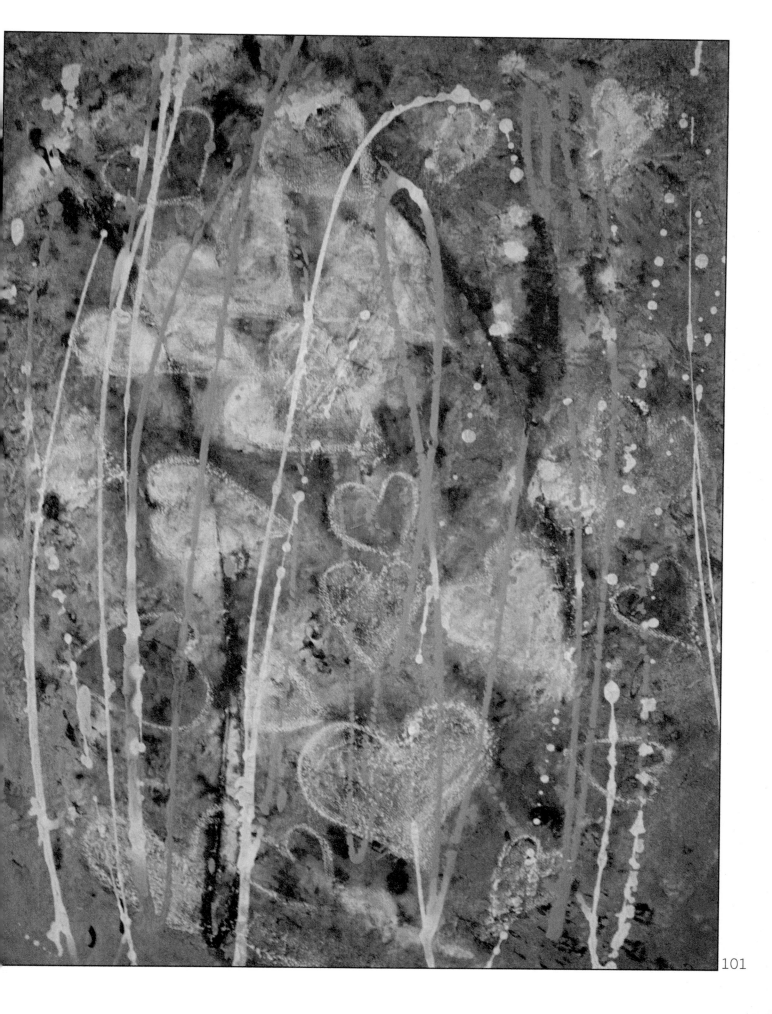

You didn't choose
to move with me
where I was going
so I tried to follow you
but ended up in nowhere
that's why we can't walk together
since you can't move
and I can't stay
here
in nowhere

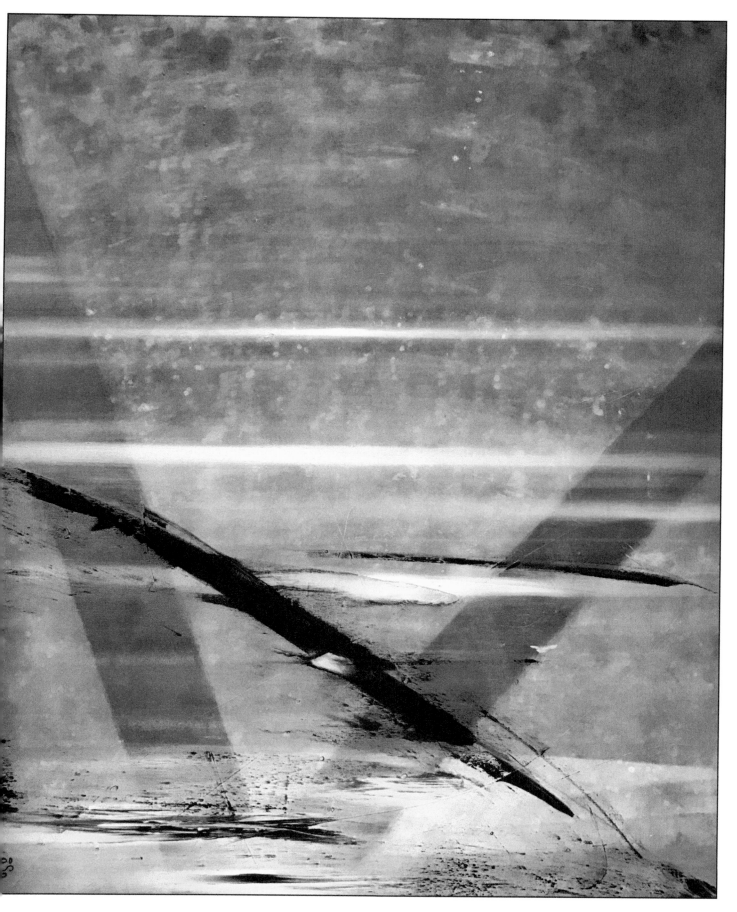

Where do we go
when we've been everywhere
when every end is dead

Where do we turn
to get home
when all the street signs
are gone

Where do we look
when we've lost
all our sense
of direction

And there is no one there
to tell us where to go

But a silent whisper in your heart
telling you to turn
and look
inside

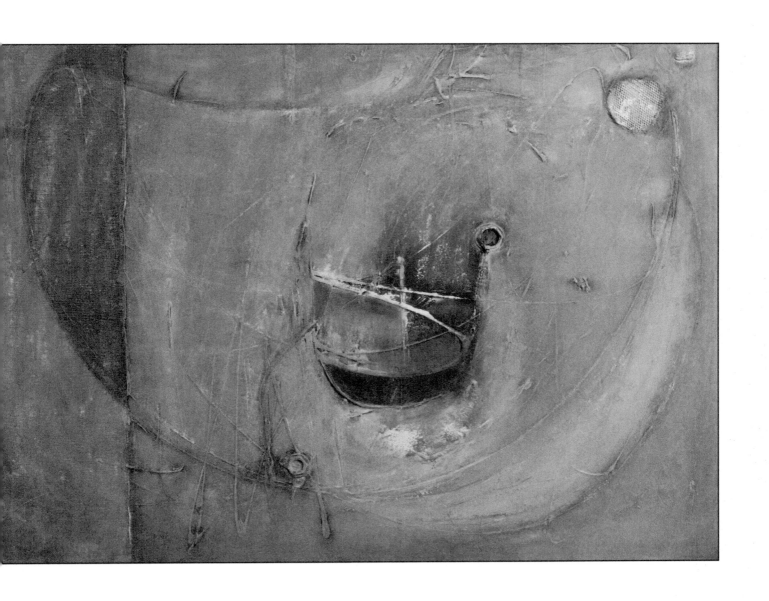

A touch of hope
is stroking my tears
away

A silent hand
is leading me
away
from the broken dreams
that cut my heart
and putting a bandage on
to stop the bleeding
from messing up
the leftovers
of my life

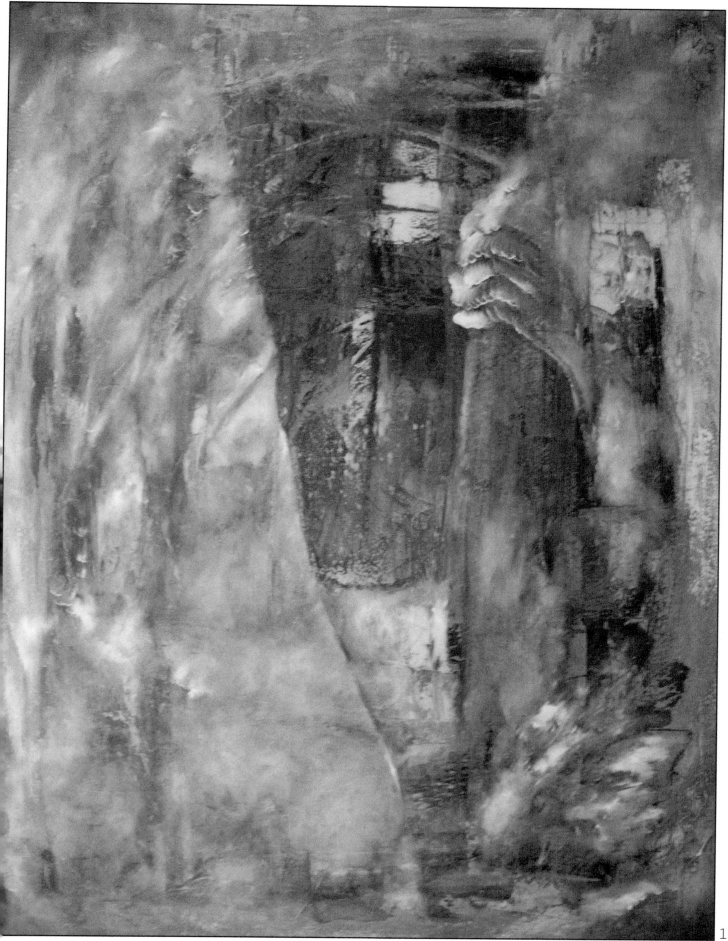

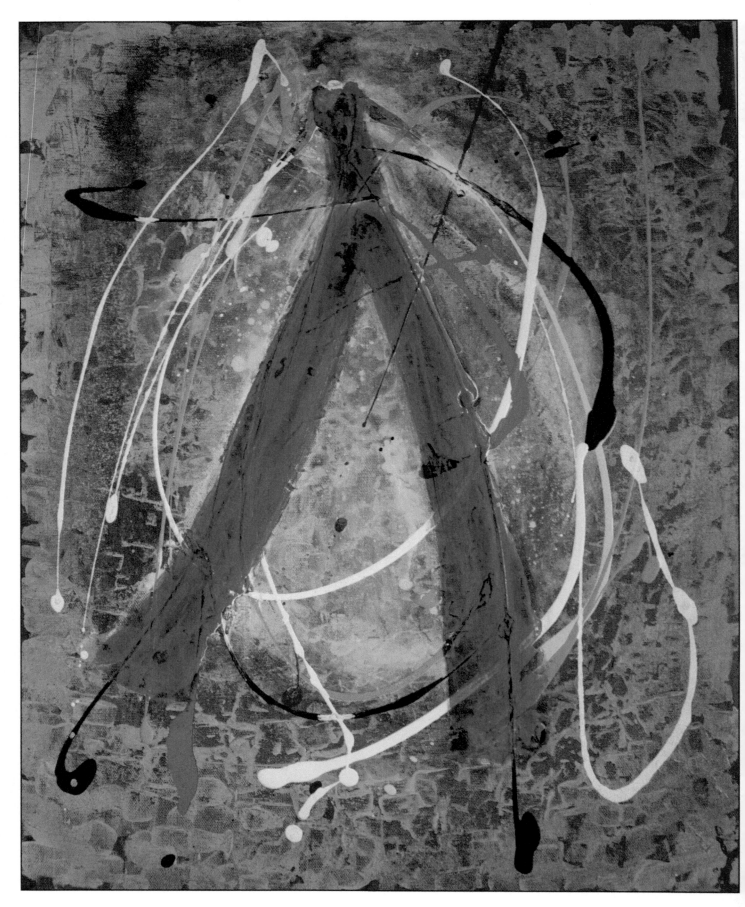

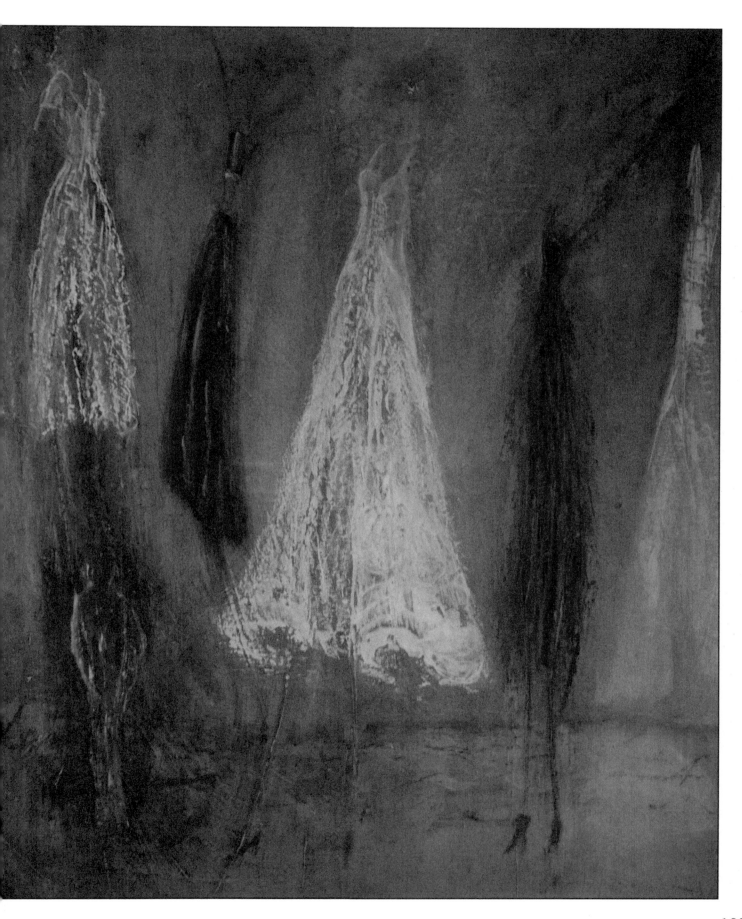

Seeing your face
brings me so much inspiration
I could write ten stories
from that face of yours

But your stories are yours
to write
and until then I will just keep reading your face
so full of horror
it scares me so

I'd like to jump to your happy ending

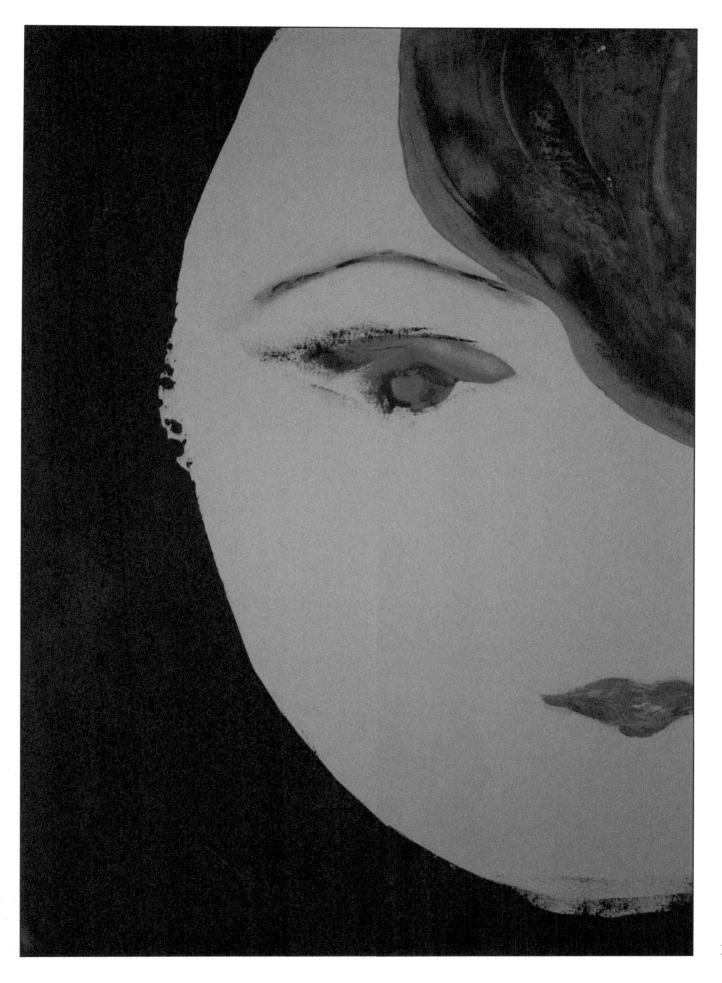

Your teeth need to be straightened
she said not showing
her own perfectly straight ones

My friend Ingrid had done that
four operations and three visits a week
two pounds of metal around her teeth and neck!

Dr. Anderson didn't think so
I answered very calmly
He thinks they will grow just fine

Did he? she said sounding suspicious
Why don't you go and ask him
if you think I'm lying? I said
knowing her pride would help me hide my lie

My teeth still need to be straightened
my friend Ingrid has a very perfect smile
and Dr. Anderson is dead
but my lie is still alive
teaching me something — I hope

(That lies don't straighten teeth
but they are easier to hide
especially if you smile!)

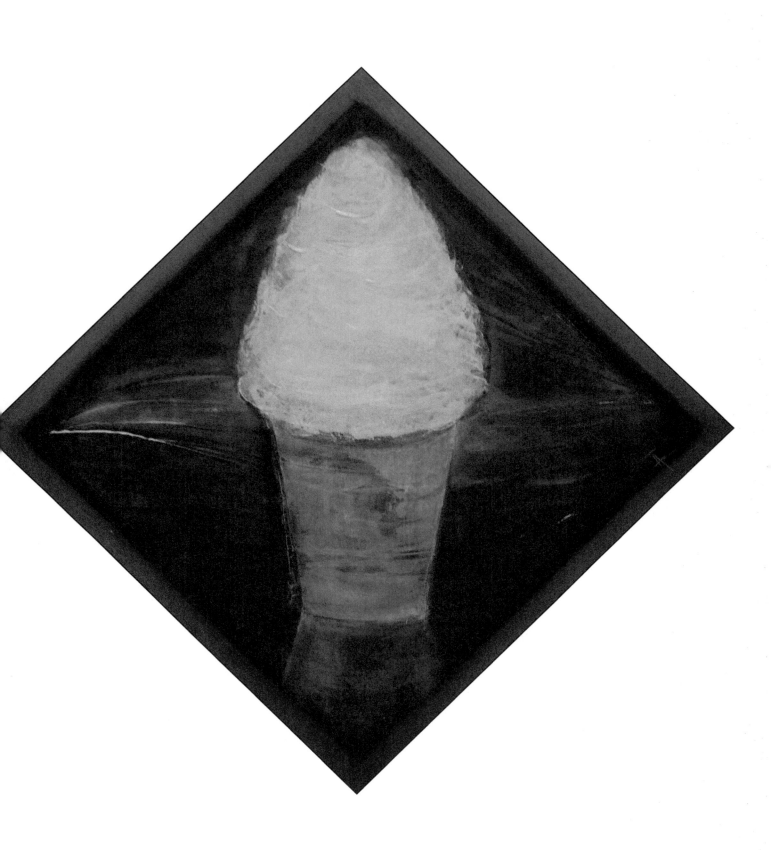

My longing
my hunger
leads me to the refrigerator
late at night
I want all of it
but not one single thing
appeals to me
in the moment of choosing
I feel hungry for something
that just isn't there
I keep looking
and taste something that just makes me fat
and I go back to bed
with cold feet
still hungry
with a heart full of question marks
drilling their way
into my empty stomach
full of loneliness
hoping the TV
will rock me to sleep...

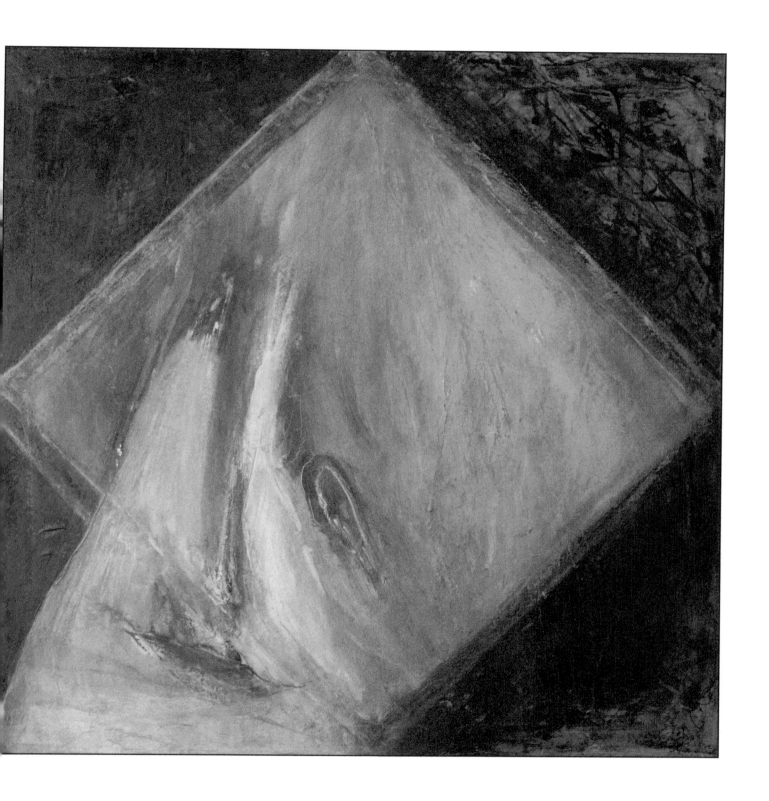

It's hard to kiss
a handful of snow
without getting a cold nose
and tears in your hand

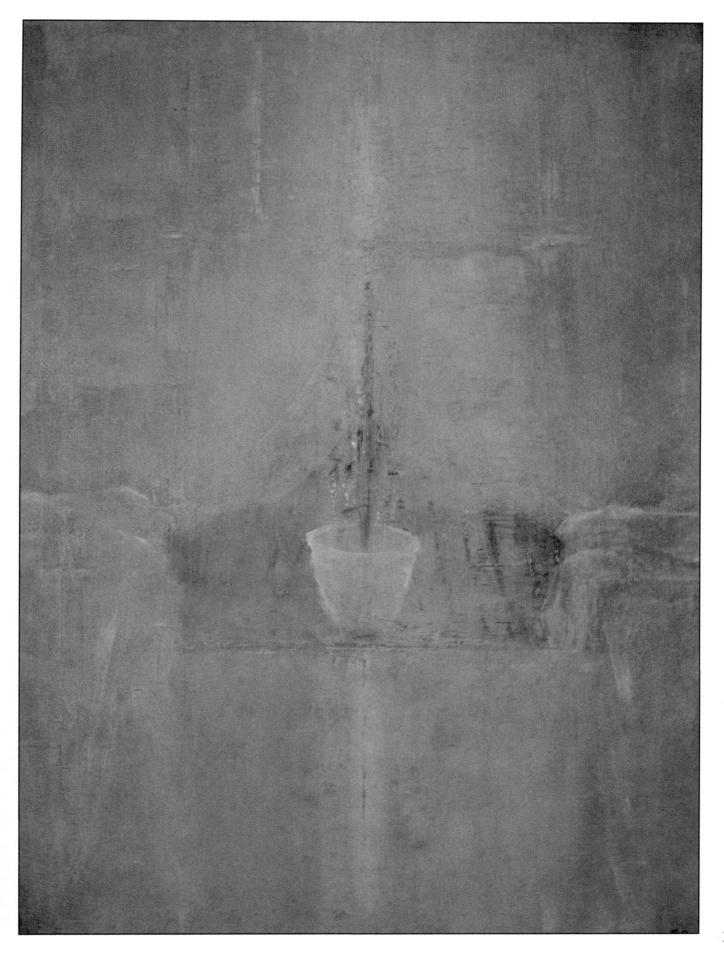

The Frost is gripping the throat
of the Morning
slowly slowly
he lets her go

But the flowers are already dead
and the ground is white

Where can she go?
the Morning never had any shoes

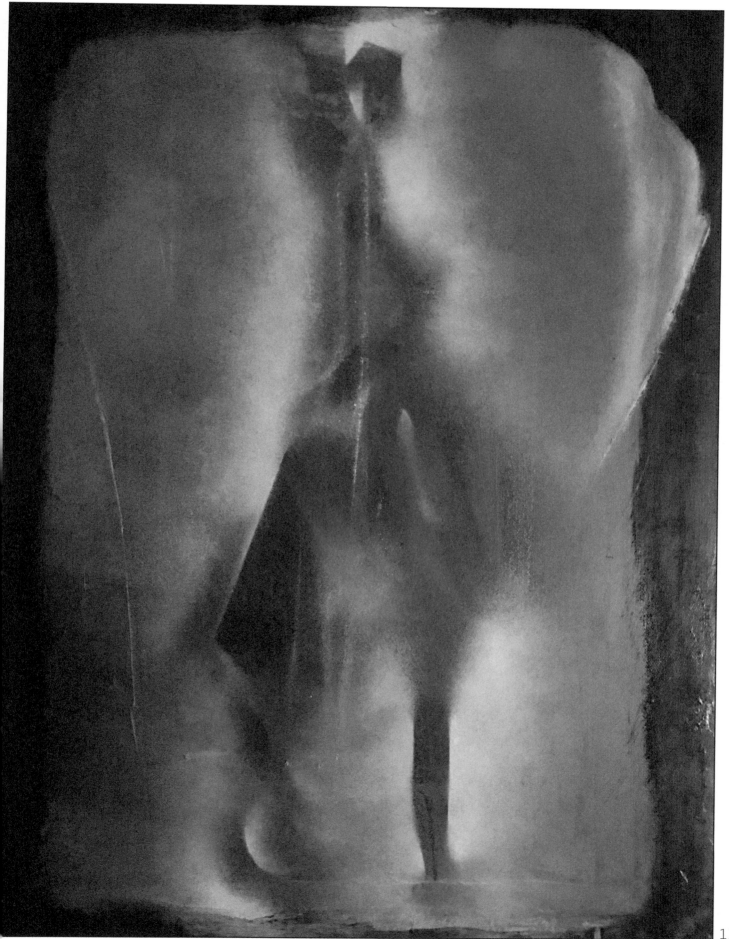

Open the window
little one
to that secret chamber in your heart
open the window
little one
and let the sunshine in
and warm your pale and skinny arms
that have wrestled so long
with the massive door
with double locks of pain and loss

But

Open the window
little one
and let the light in
and you
out

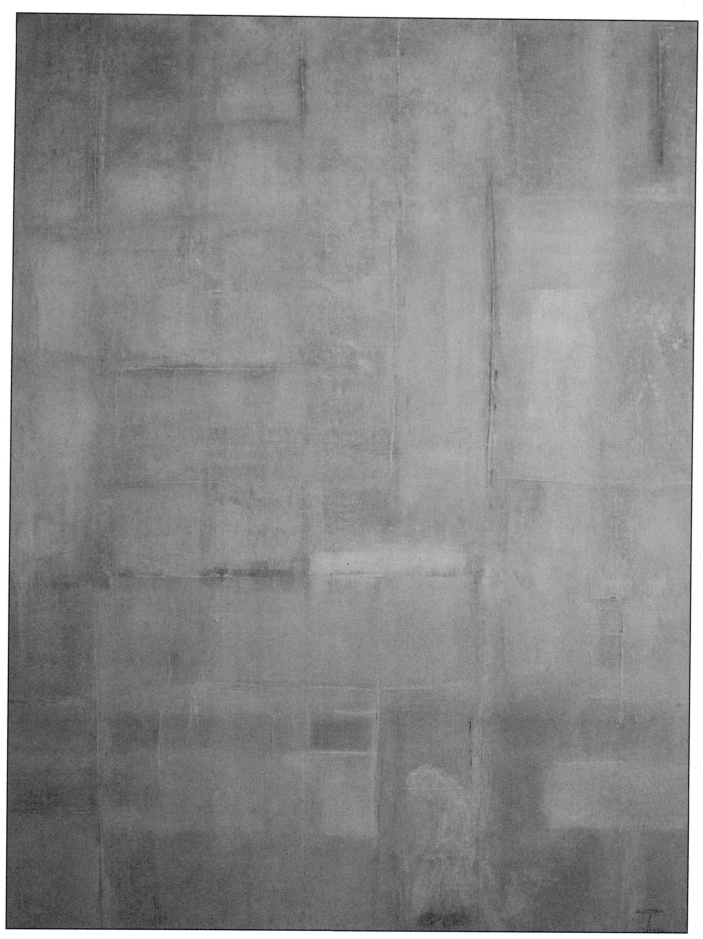

In the depth of the forest
lies a little deer
not a word
not a movement
she is frozen
quiet
the sun rises
the fog is lifting
the birds start to sing
and the ground is warming up
but the deer is melting
into the ground
her eyes will never again
see another day
but you may feel
the breath of her body
the sound of her soul
disappearing
like the soft wind
through the leaves
waving goodbye

And the heavens are opening up
for one little deer
ending its journey
too soon
by the hand of a man
who could not help
but pull the trigger
of a gun in his hand
with one bullet
he just needed to shoot
and did not bother
to see where it went
since he just likes the shooting

But he didn't mean any harm

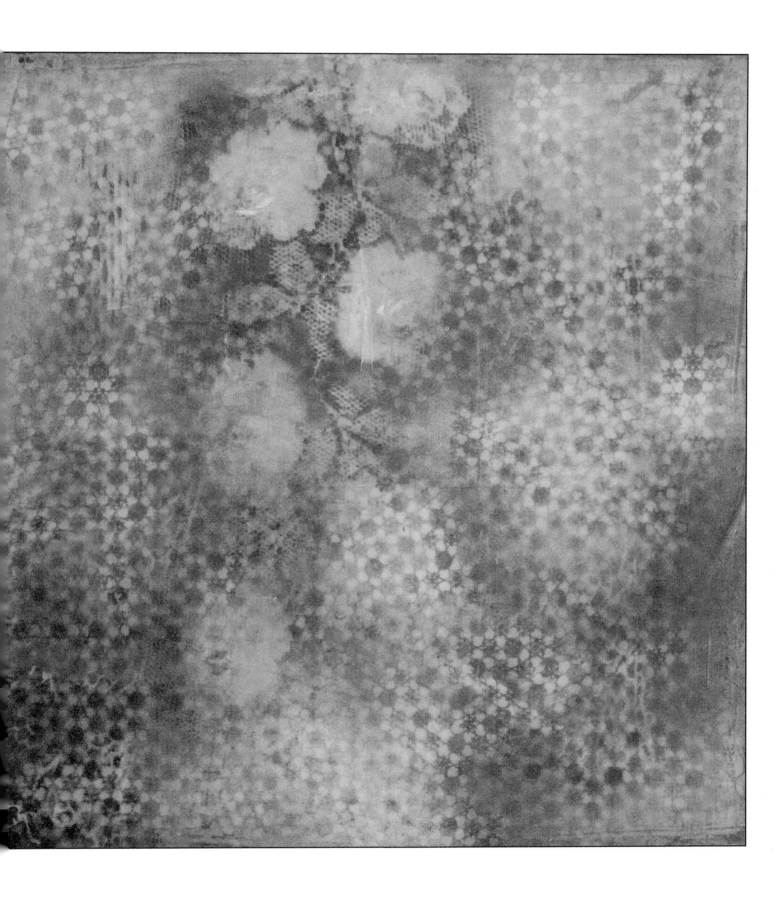

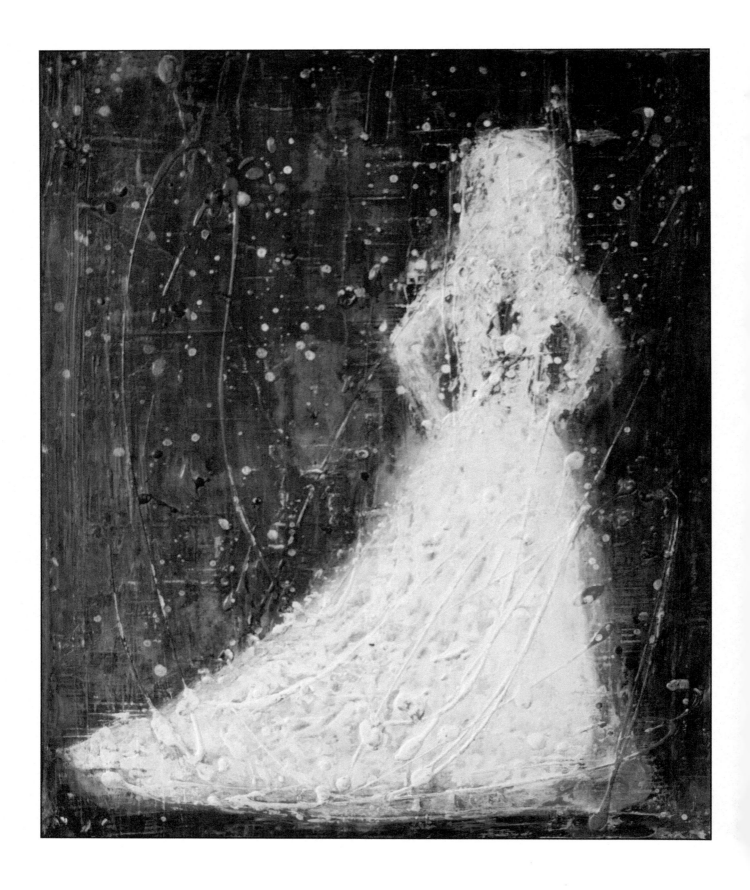

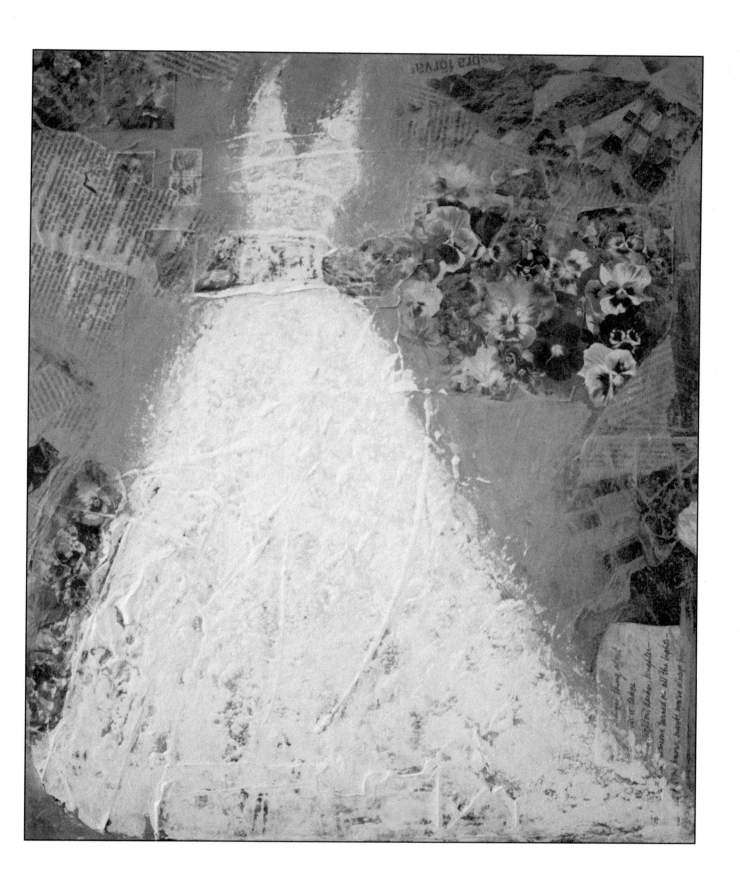

One day
waking up
with a hangover
in a haze
of forgetfulness
filled with unclear faces
with a bag of wrinkled memories
hidden in the closet of your mind
wondering
what you did
with all the yesterdays
of your life

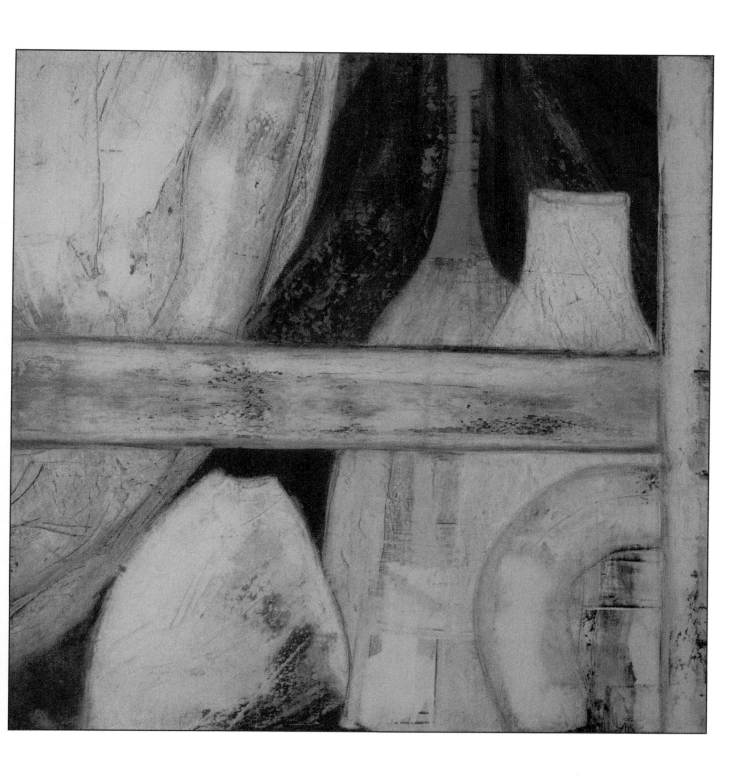

Perhaps it is already gone
like the stars we see are no longer there
the movies on TV are made a long time ago
the actors have moved on — some are even dead
the meats we eat are remains of animals
who are dead and no longer here
the songs we hear are music
made in studios weeks or years ago
the thoughts I think — the air I breath
I have done that before

The buildings I see
the cars and streets
are all made of thoughts
and ideas
from minutes
years or decades ago

Nothing is now
more than this very moment
which is gone faster than I can think it
so why try to hold on to anything?
It will be gone as everything else
like my life — is it already gone
has it already been lived
another time?
Am I just taking notes from a life already lived
finished and gone?
Just the secretary
finishing my tasks
secretly watching the clock
longing to go home?

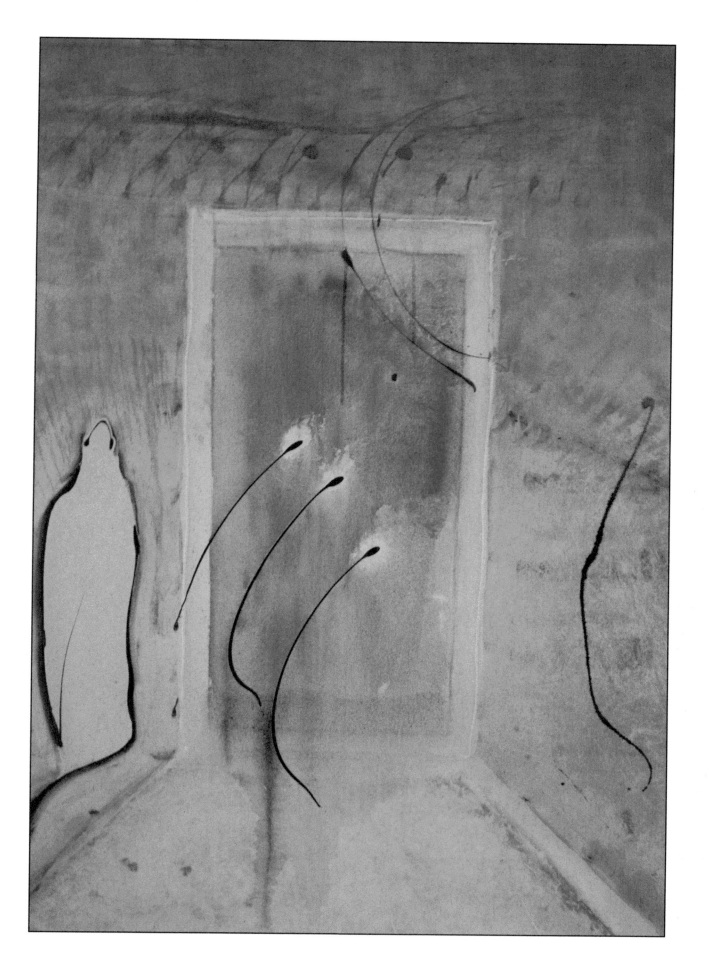

People have invented
time management
time efficiency
time control
and time planning
but don't seem to plan
for the time
when time stops

The day we don't need more time
we have all the time we need
and we can look back at what we did
with our time

Did we create smiles
in the hearts of our loved ones?
did we watch
the rainbow after a rainy day?
did we smell
the flowers in the park?

Or

Were we too rushed
by time
to have time
for all those things?

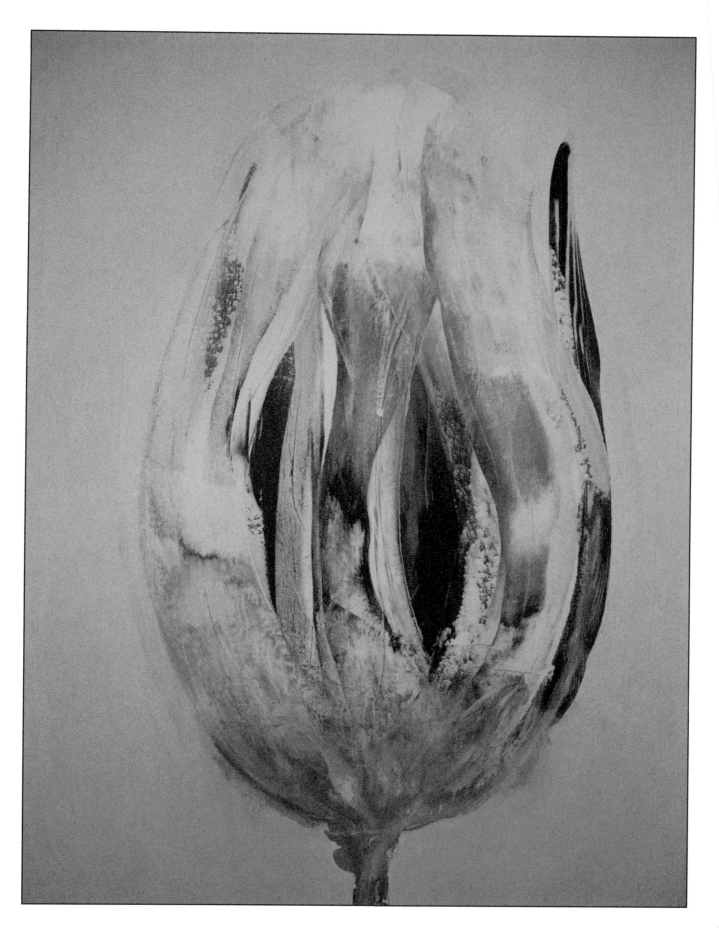

Change my heart
to a stone
a brick
a shell
without the pain
that is bleeding
yellow
between my fingers

I held that little egg
too hard
and know
that bird
will never fly

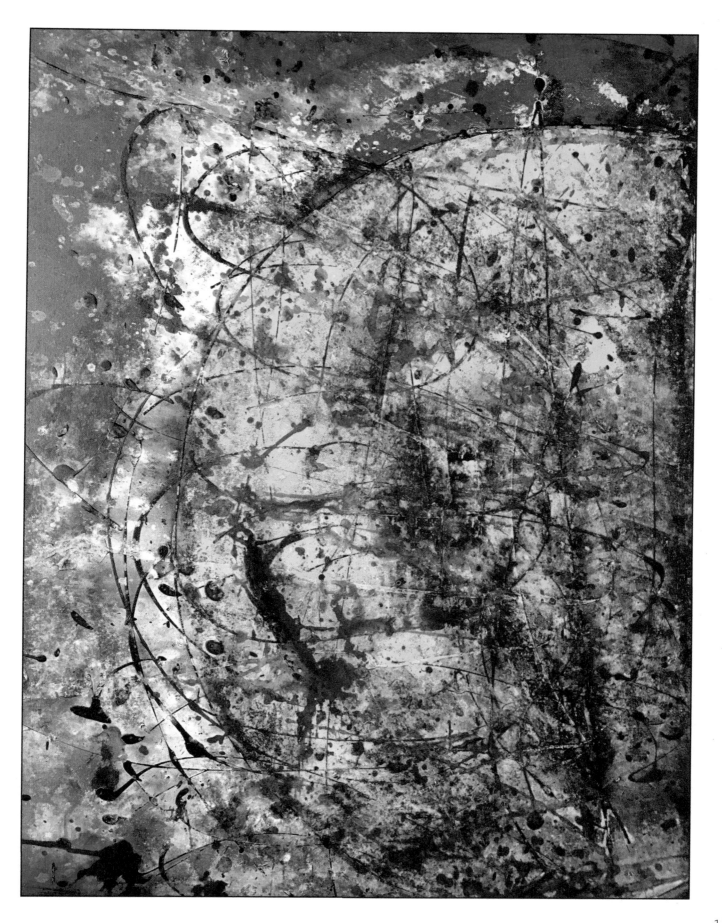

When he wrote
his lovenotes
he always used
a pencil
like he one day
might need to
erase those words

The day he wrote
me one in ink
the words didn't matter
it was not meant
to be erased
by time
by him
or me

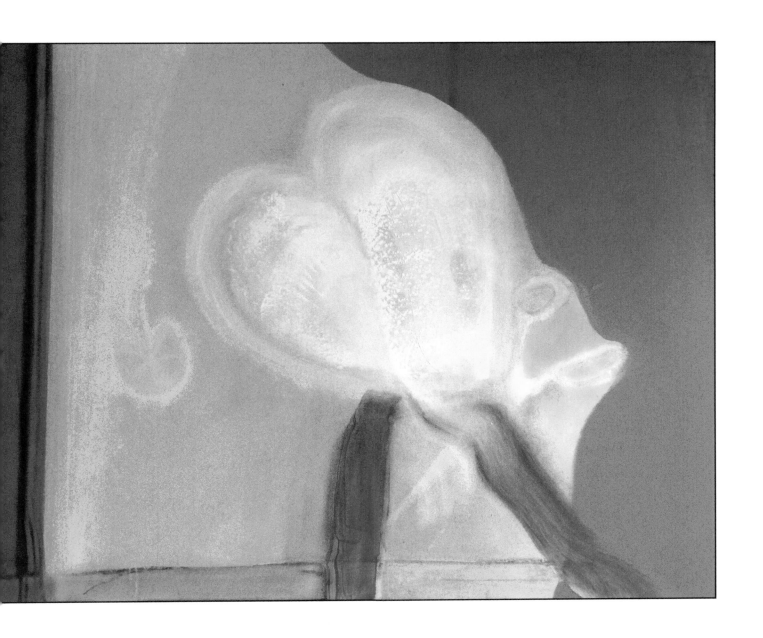

She wanted to be an author so she became a lawyer
and learned that neither of them needed to be too concerned
about the truth
that people pay them both
to tell a lie

She also learned nothing looks so naked
as a naked lie
without the fancy wrapping
ribbons and bows
the lie just lays there naked
like a snake
without the skin
staring at you
and no matter how much they sing you Happy Birthday
you just know
it isn't

And you go to bed that night
in expensive underwear
and there lying next to you
is that lie
looking at you
you close your eyes and embrace it
and the two become one...

And no matter how often you tell yourself
this is your life
you just know
it isn't

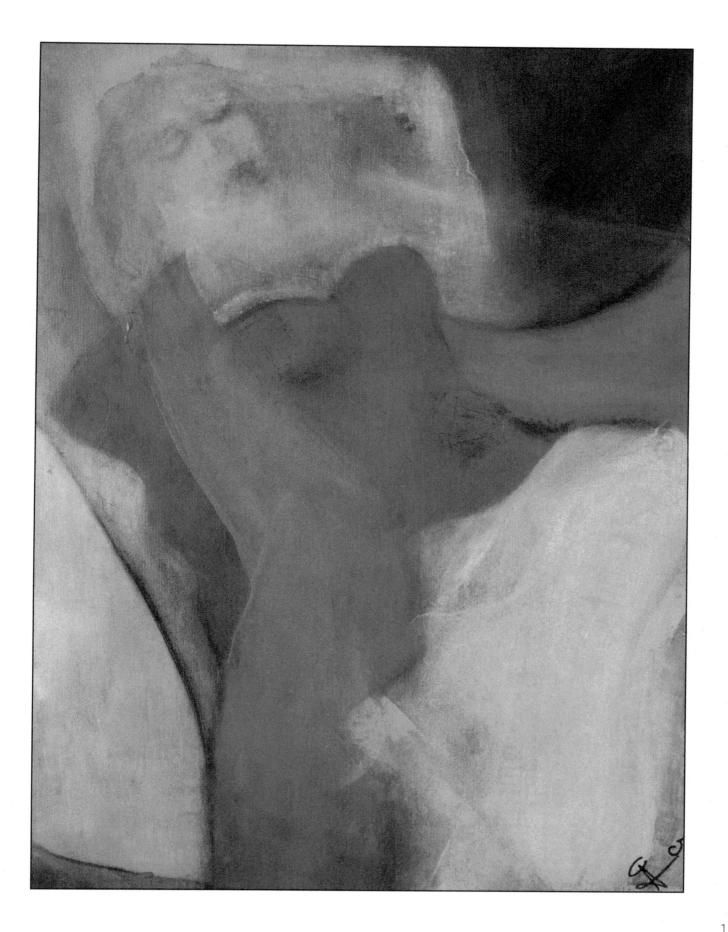

Learning to be by myself
stand by myself
love myself
accept and forgive
myself
there are a lot of my selves
in my life!

Maybe I'd like to be
someone else
for a while
and give myself
a break

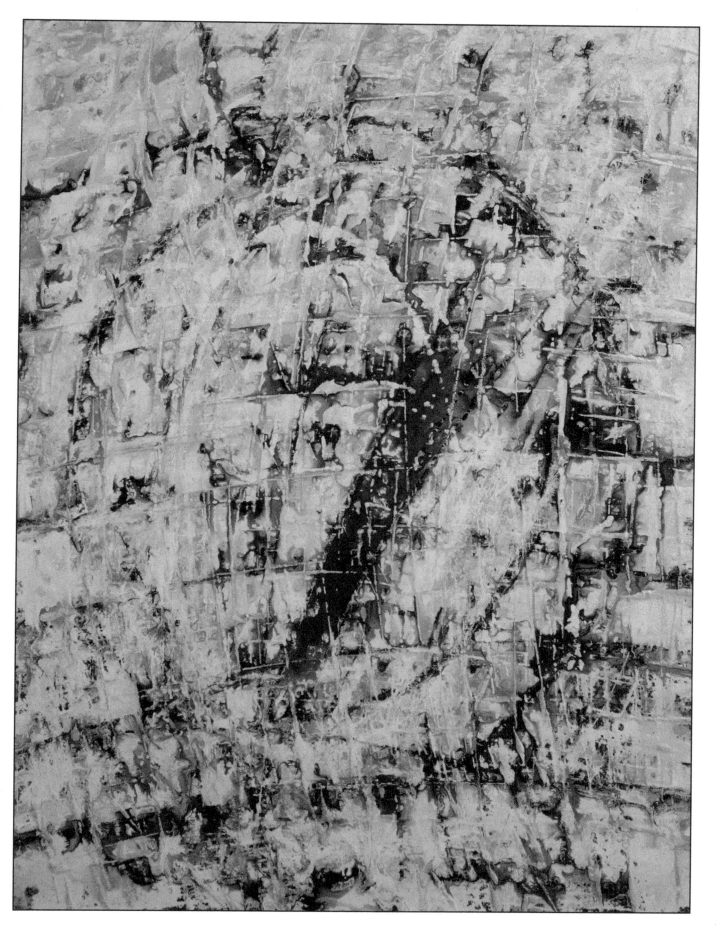

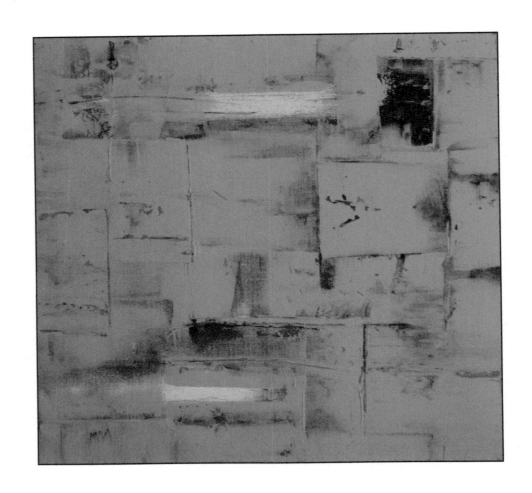

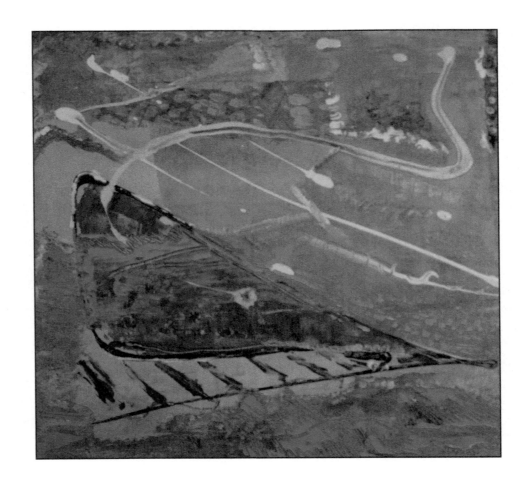

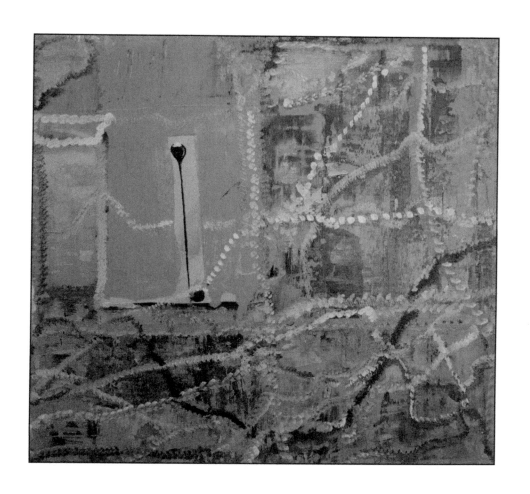

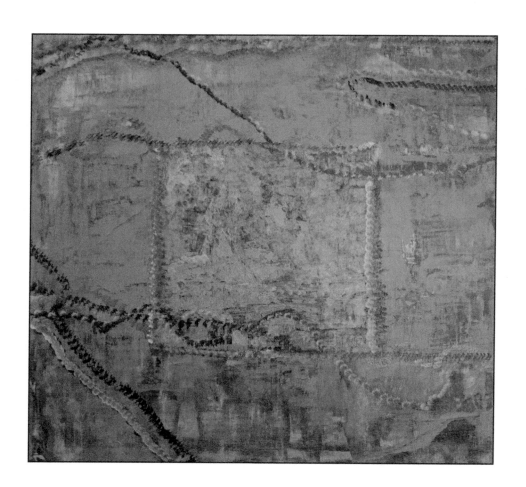

What kind of mother am I
that month after month
prevents my child from being born?

What kind of mother
has no child?

A cruel one
a lonely one
or just a different one
perhaps who loves her children too much
to let them be born here

Just think what I could have been
if my mother had been that kind

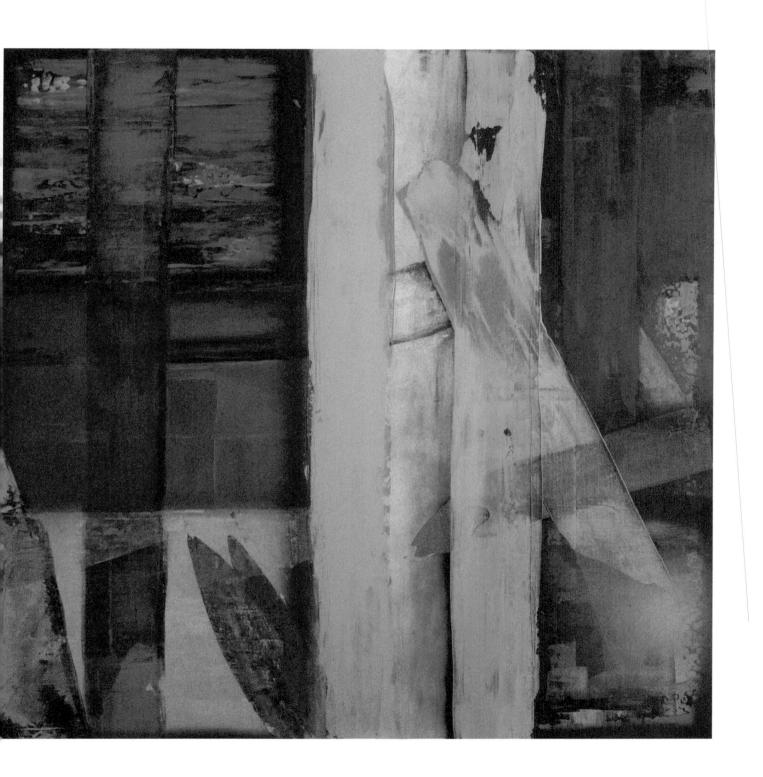

143

My sweet little cat
from the land of Ambrosia
the land of nectar, honey and smiles
how you curl up to me
and put your cold little nose
under my palm
filling my hand
with sweetness of the Gods
from a land so far away
of Ambrosia

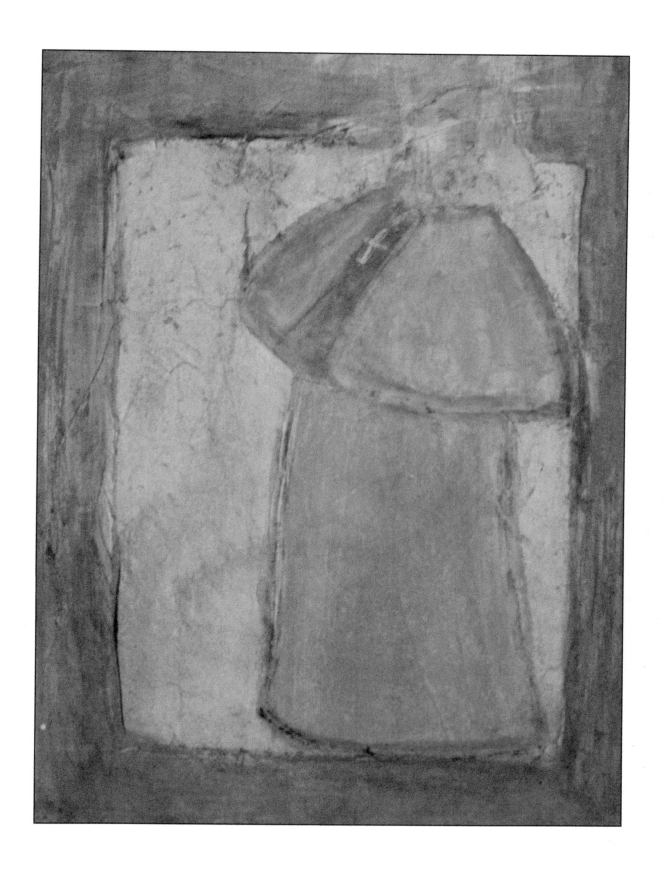

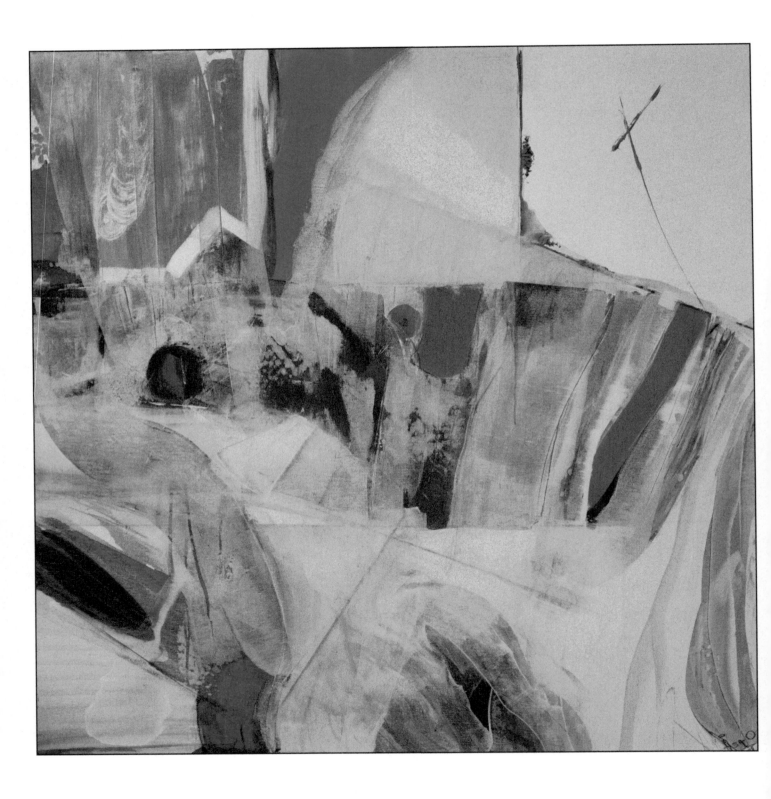

146

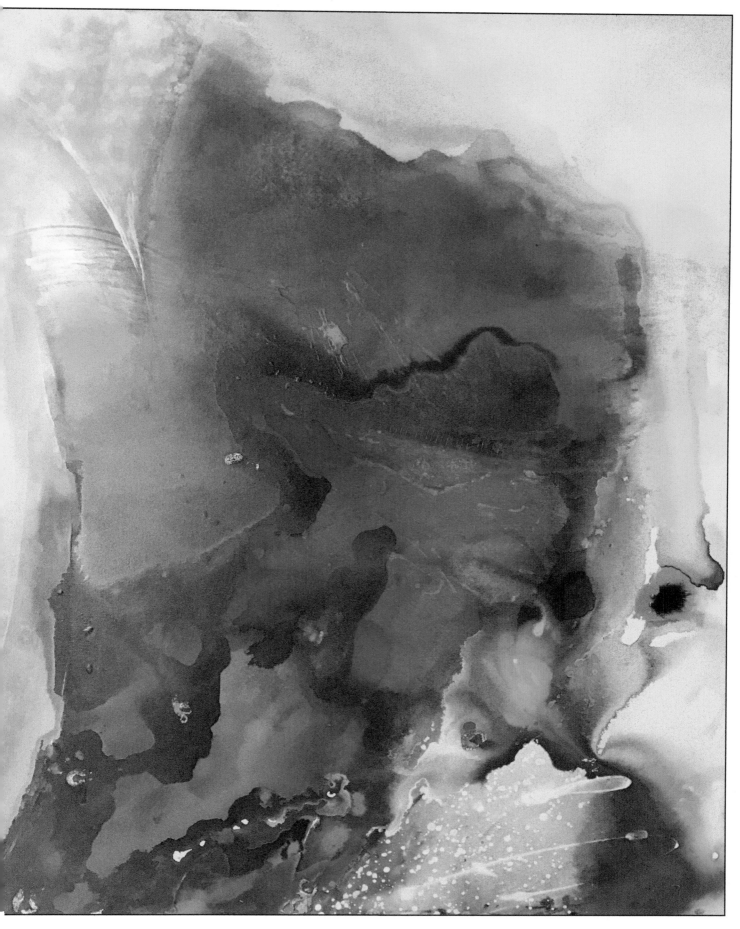

My favorite tree
I never climbed
I laid and looked up at her beautiful crown
I hugged her trunk
I breathed her oxygen
I used her shadow
and she transplanted her calm
to the skinny me
but I never climbed her
my favorite tree

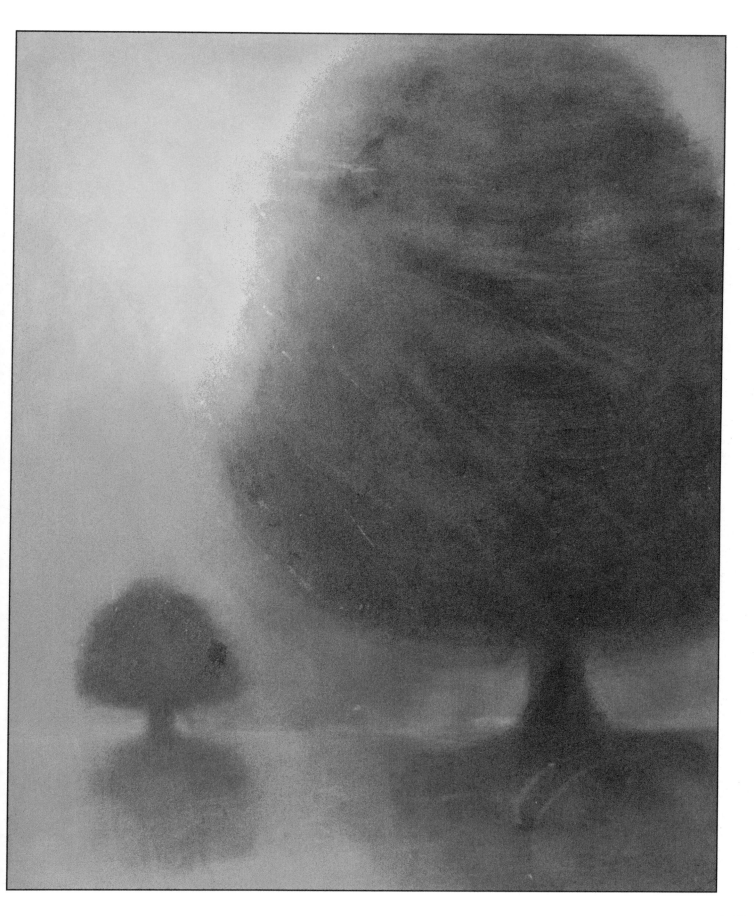

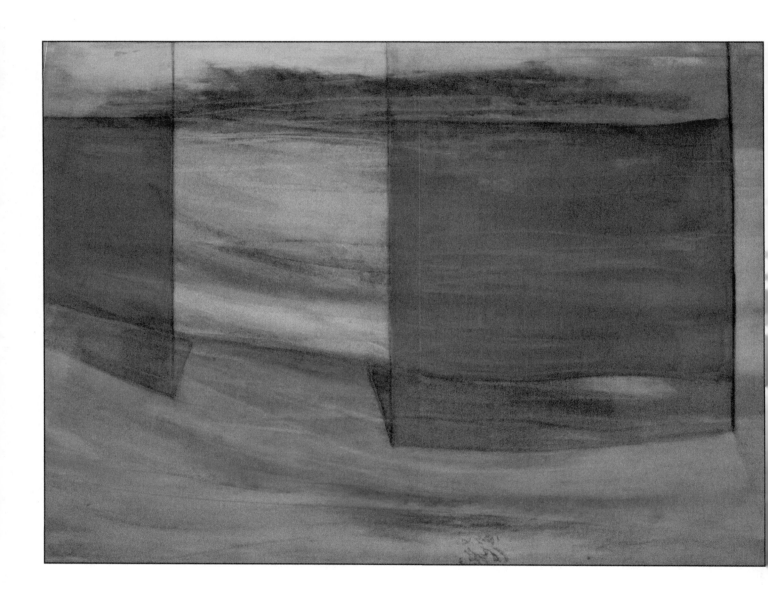

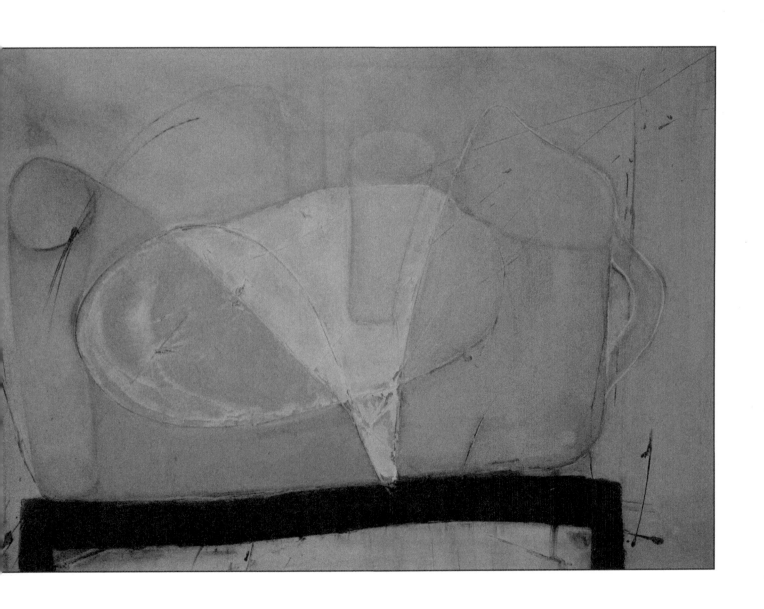

Seaweed and salty water
strong sun under clear skies
where can one hide
a rather pink
and chubby body
trying to get shelter in a too small bikini?

The beach doesn't take refugees
but ruthlessly undresses us and extradites us
to our enemies
like that tanned young beauty
who passed us
leaving no footprints
in the sand
but deep ones in the mirror
of your mind

Never again will I love to put my naked feet
on the warm belly of the beach

I will wait for storms and rainy weather
and then I will be back
walking all over her
with my hard rubber boots leaving footprints
too deep
for the seaweed and salty water
to erase

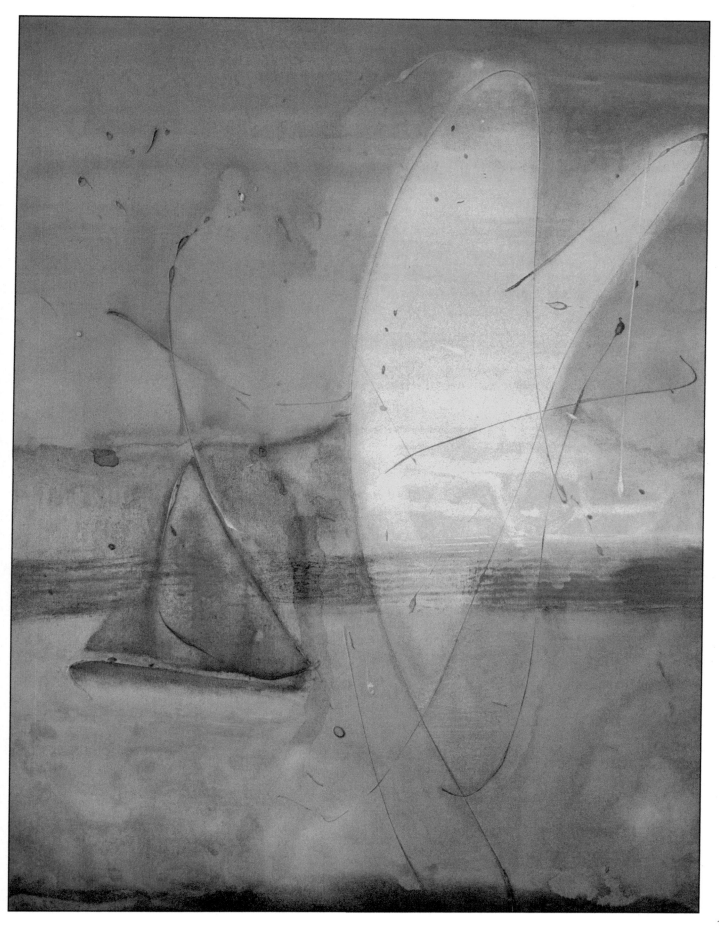

A millimeter
is a short space
to measure
between two people
that love
and live to be close

A millimeter
is very long
when you need to move
and just can't
because something is pulling you back
like your past
filled with memories and beliefs

A millimeter
can be a universe
taking eons to cross
in the spaceship of your mind
when your free heart can cross it
in no time at all

A millimeter
is no space at all
or miles of trails
depending on the vehicle
a memory
or a heart
willing to change
the distance

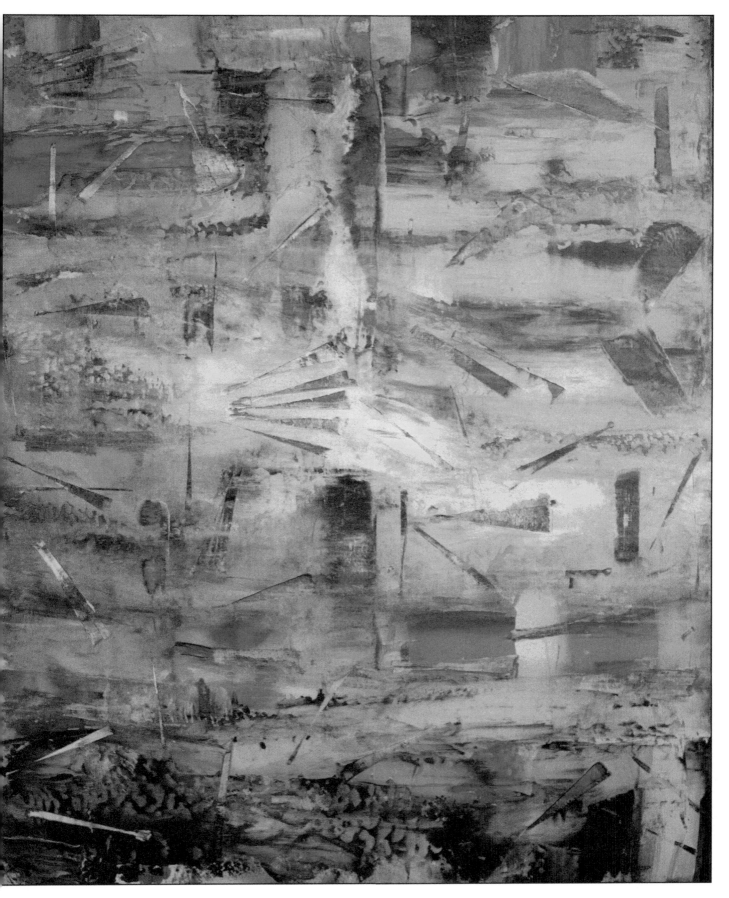

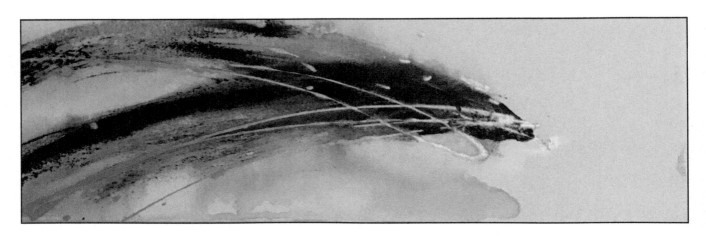

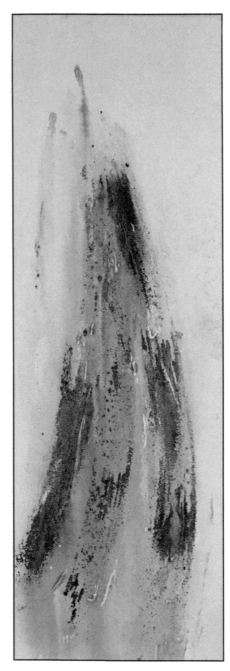

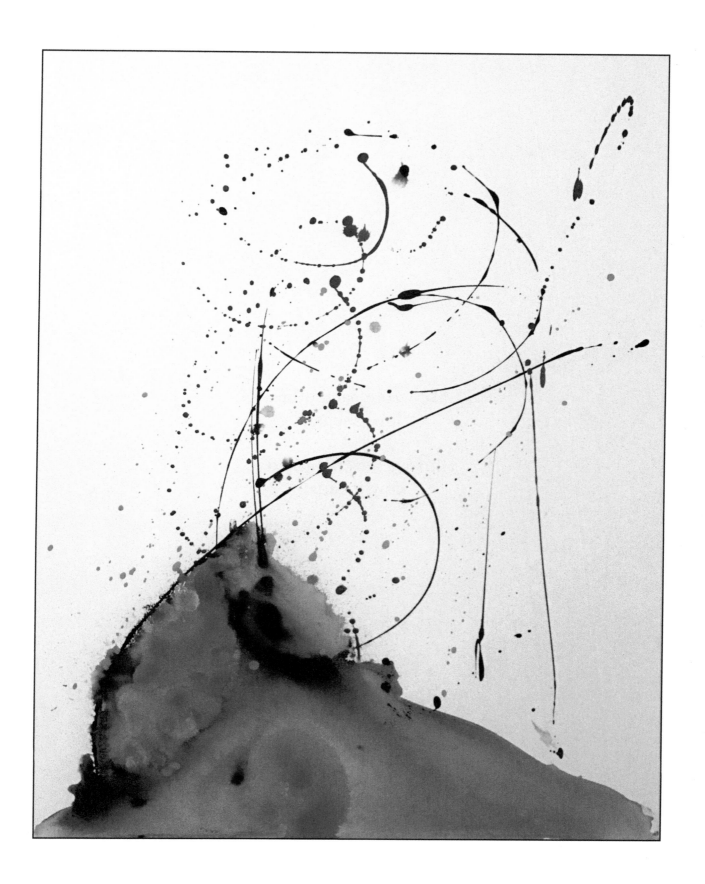

We wrote each other
love songs

But we never learned
how to sing

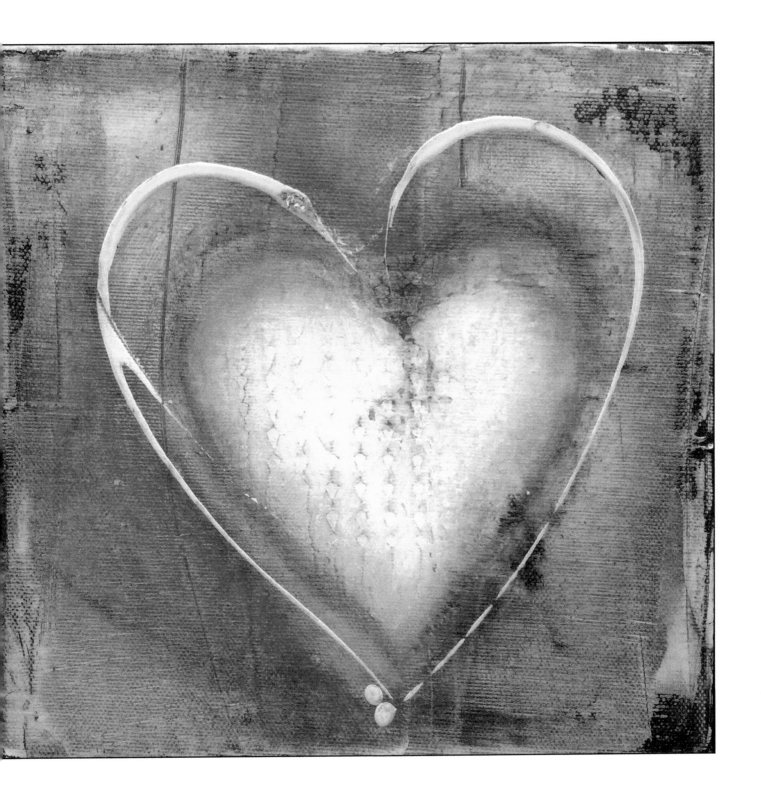

Someone always carries me
and gives my feet security
someone's always holding me
making sure I don't fall off

Someone whispers quietly
through the nature
through the trees
and in my deep sincerity
I kiss the earth

On my knees I hear a cough
from a rock below a tree

Who would ever have thought
that Earth could have a cold

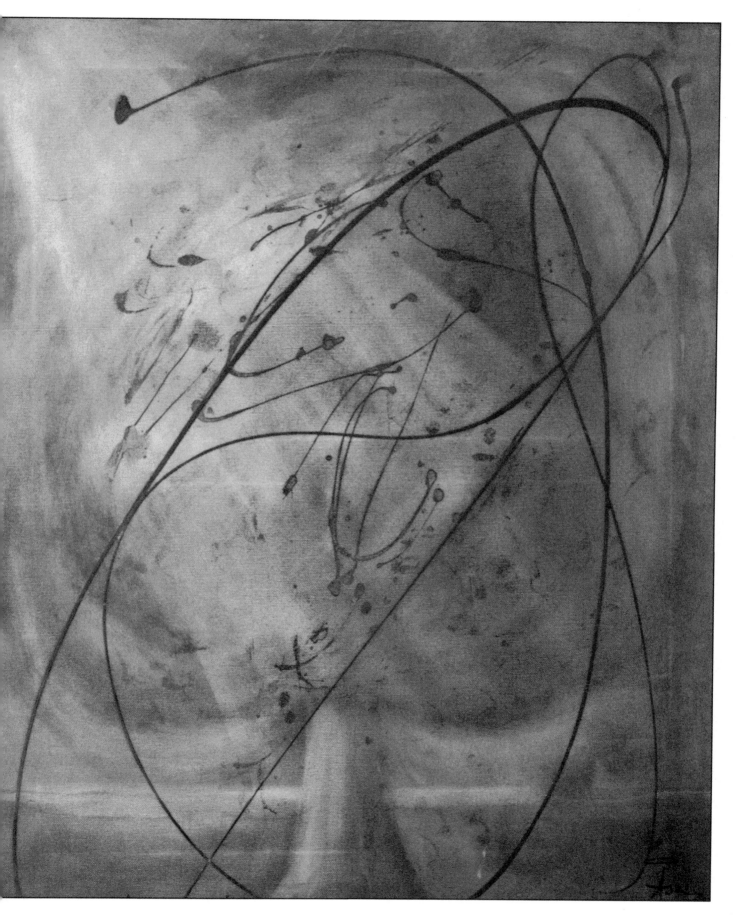

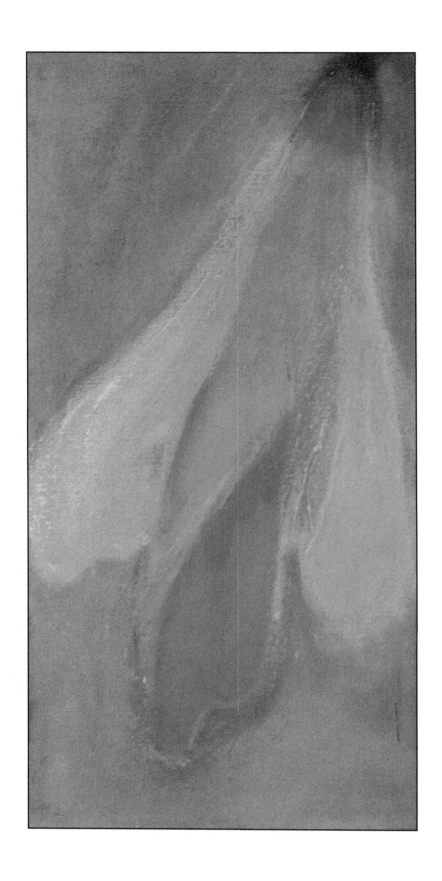

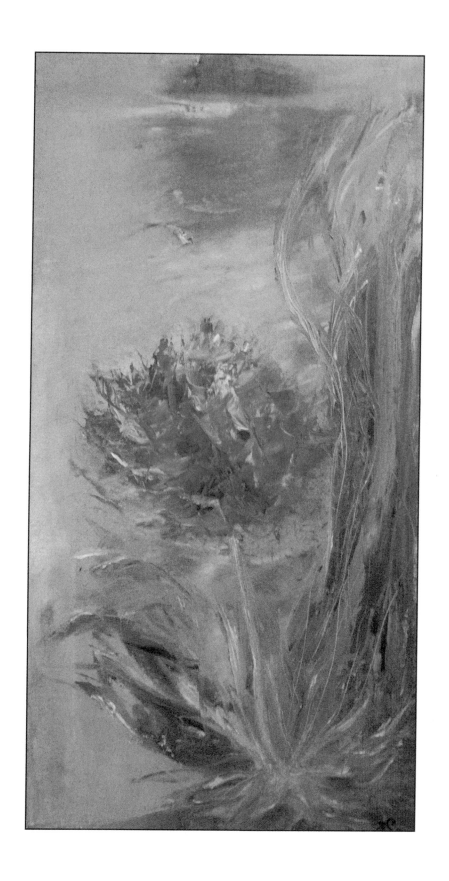

A new page of life
has written itself
word by word it's revealed
sentences for us to read

But reading doesn't mean understanding
sometimes we need to read the whole page
sometimes we need to read the whole book

but still we realize that each word
each page was necessary
for us
to get to that understanding
of the last page

And we close the book
in thankfulness
for each little word
that wrote our book
of understanding

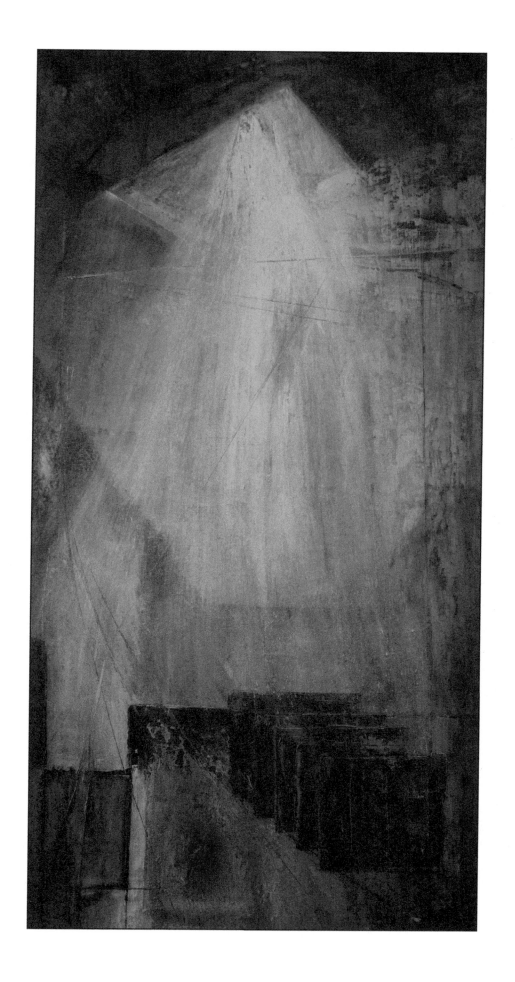

Where the sky turns into Heaven
there is where the angels live
there is where the blue sustains
and goes to earth like water
I will meet you there
once again my friend
when we can lift beyond the shadows
and the sky connects
and touches the earth
and turns it
into Heaven

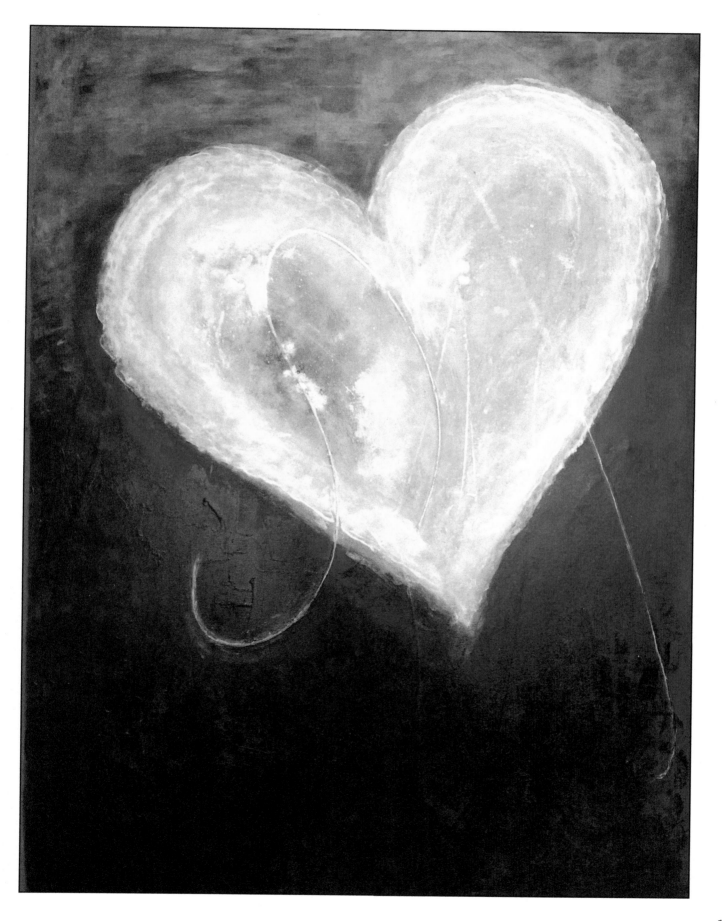

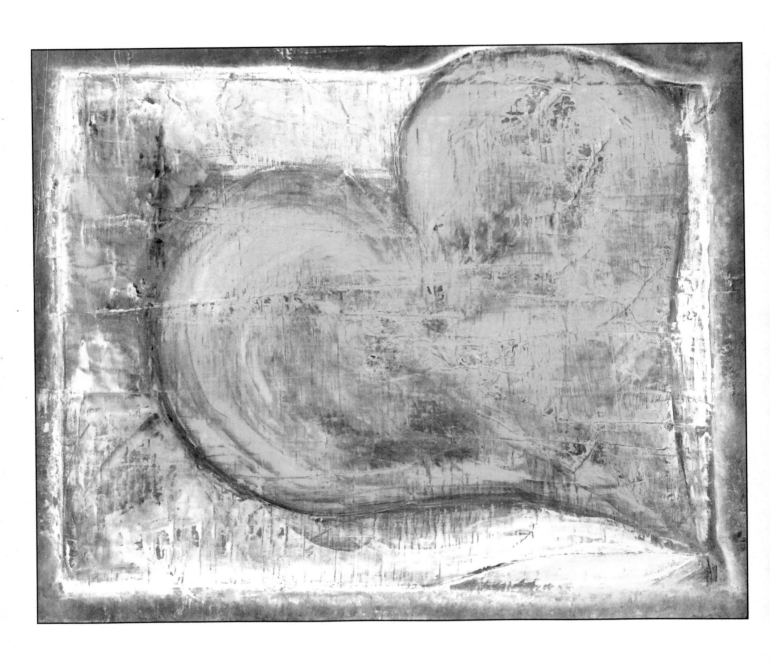

Thank you!

Dear reader, thank you for coming with me on this journey of healing our hearts together, and opening up to experience a life filled with love and joy — the life you deserve!

When our hearts are healed and open...

We extend our compassion and loving for everyone, not excluding anyone.

We do not look for what is wrong with one-another — recognizing we all carry similar burdens — but delight in what is good about ourselves and each other!

We do not fight for peace, we become peace.

We do not dwell in the past, but focus on creating a beautiful now and future.

We look for the best in each other and focus on creating connections and laughter.

And we smile as we meet again...

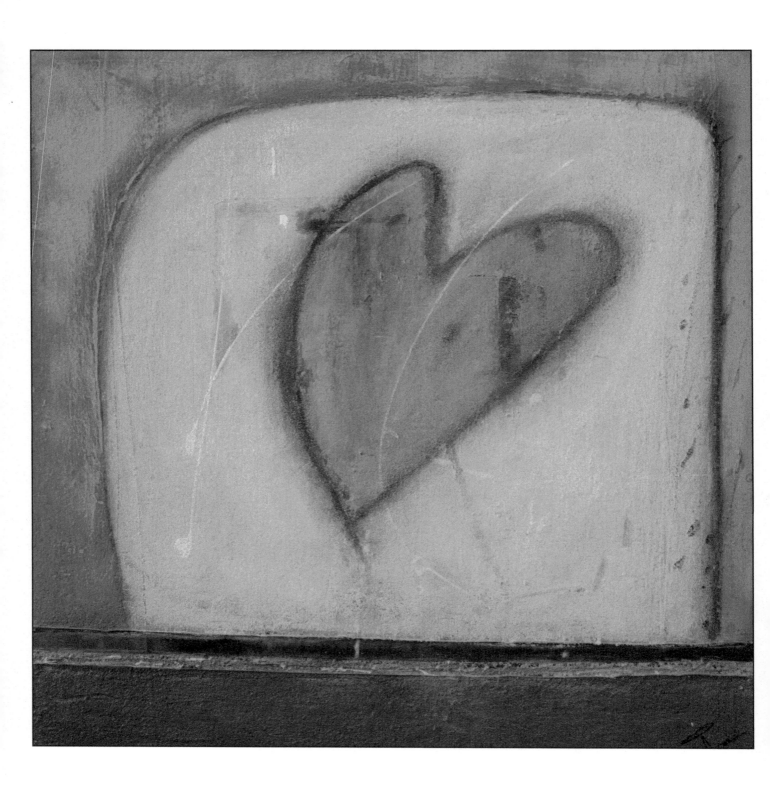

Tack!

Many beautiful people have come forward in my life to help me open my heart during the last 35 years. To my five sisters, Maj, Lena, Marie, Bodil and Eva and extended family, good friends and spiritual family, thank you all for being with me on this winding journey! I am deeply grateful to you all!

I would especially like to thank those of you who have inspired me to create this book...

Darlene Whitehurst, thank you for showing me what a difference my paintings and poetry can make in times of tremendous grief. Your gracious gratefulness and appreciation of my art and poetry touched me so deeply that I finally felt I had to make this available for people who were looking for comfort and support in hard times.

Patty Aubery, thank you for your incredible enthusiasm, appreciation of my art, and support of my writing. You are my muse in many ways as you help me value what I have to offer as something the world really needs.

Jack Canfield, thank you for heartfelt support and belief in us from the very beginning. It takes a bright star to step forward and shine the light on others.

John Morton, Michael Hayes, Sally Gray, thank you for standing by me and helping me heal my own body and heart.

Lance, thank you for supporting and appreciating my art from the very beginning.

John Roger, my spiritual guide and teacher, thank you for patiently nurturing me on my long path home, for teaching me most of the things I know about spirit, loving and joy, and for always making my heart smile!

My three incredible and talented sons, thank you for opening my heart!

Per, thank you for sharing your everpresent joy and teaching me unconditional love and acceptance.

Johannes, thank you for your wise insights, supportive loving, and many laughs!

And last, thank you, Émile! Without you this book would not exist. Thank you for your incredible enthusiasm and love for my art and poetry, not only in words but in jumping right into action — gently pushing me into this project. By putting not only your creativity and skills, but also your bright energy into designing this book, you've made it into a beautiful and graceful piece of healing art. Thank you for continuously showing me where the light switch is with your wonderful acceptance and humor! Working with you is such a joy!

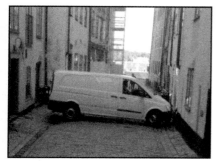

Émile delivering paintings for my Heartquakes show at a gallery in Old Town Stockholm. Just another example of Émile's attitude: "Nothing is impossible – sometimes it just takes a little longer!"

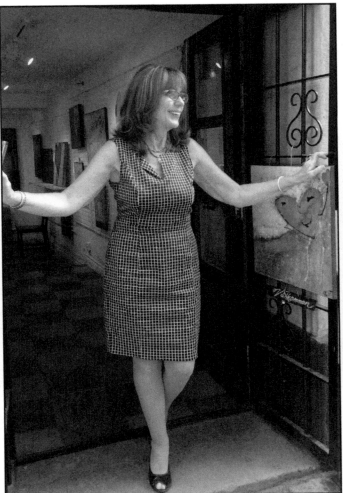

Meet Åsa Katarina!

Åsa Katarina Odbäck grew up in Sweden, where she graduated #1 in her class from Law School, after which she taught law at the University of Stockholm before proceeding to graduate #1 from Stockholm Business School. She then founded a major success training firm that worked with international companies like Volvo and Ericsson. Later, she served as head of Press and Information for the Swedish Defense University before moving to California where she raised three boys, authored five books and started a company to support female artists. While fighting a serious illness, Åsa used art to heal her body and heart, and has since created over 200 paintings. Her art is universal and has been appreciated all over the world. Her most recent shows have been in Los Angeles and Stockholm.

Certain pieces from this book are available for showings and purchase.
For more artwork, information or questions, please visit...

AsaKatarina.com

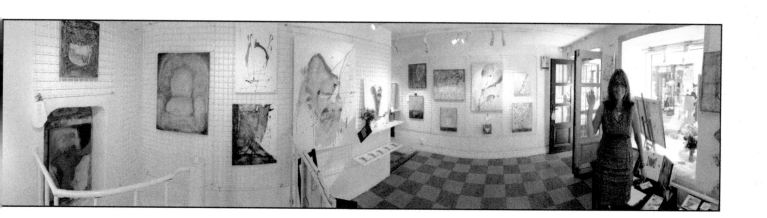

CPSIA information can be obtained
at www.ICGtesting.com
Printed in the USA
BVOW10s1017020117
472354BV00024B/263/P